*Struggles with the Image*

YYZ Critical Works

Forthcoming publications in the 'YYZ Critical Works' series include:

*Jeanne Randolph: Collected Essays*
*Critical Writing from Quebec*

# Philip Monk

# Struggles with the Image

*Essays in Art Criticism*

YYZ Books, Toronto

Series Editor: Bruce Grenville

YYZ Gratefully acknowledges the assistance
of The Canada Council and the Ontario Arts
Council toward the publication of this book.

Published by YYZ Books
1087 Queen St. W.
Toronto, Ontario
Canada  M6J 1H3

Printed in Canada.

Canadian Cataloguing in Publication Data

Monk, Philip,
    Struggles with the Image

(YYZ critical works)
Bibliography: p.
ISBN 0-920397-06-9

1. Art, Canadian. 2. Art, Modern — 20th
century — Canada. 3. Art criticism —
Canada. I. Title. II. Series.

N654.M6 1987     709'.71     C87-094847-4

# Contents

*Preface* 9
*Acknowledgements* 11
*Introduction* 13

I  Struggles with the Image
*Exits* 21
*Violence and Representation* 29
*Breach of Promise* 35

II  From Drift to Dialogue
*The Zero Machine* 45
*Coming to Speech* 63
*Language and Representation* 79

III  Semiotics of Reception
*Colony, Commodity and Copyright* 91
*Staging Language, Presenting Events,*
  *Representing History* 111
*Editorials* 131
*Axes of Difference* 185
*Subjects in Pictures* 209

*Bibliography* 217

# Preface

Philip Monk's *Struggles with the Image: Essays in Art Criticism* is the first of a series of books which are intended to reassert a role for critical writing within the development of a history of contemporary art in Canada. In gathering together and reprinting this series of essays we are inviting the reader to (re)consider the importance of their contribution to the development of contemporary critical writing.

The eleven essays gathered here are drawn from periodicals and catalogues which were published between 1980 and 1984. Together they trace a trajectory across the critical issues of contemporary art and art criticism. The other books in this series will trace different routes. As a group they will contribute to the building of a history of contemporary art in Canada.

The production of a book such as this requires the united efforts of a large number of people. First and foremost I thank Philip Monk for his dedication to the project. The publishing committee of *YYZ Books*, David Buchan, David Clarkson, Judith Doyle, Janice Gurney, Elizabeth MacKenzie, Bernie Miller, Andy Patton, the YYZ co-ordi-

9

*Preface*

Ayearst, have all played an important role in the develop-
ment of this series and the publication of this book. Our
thanks go to Bruce Mau for his design and production of
this book, and to Kate Brown for her diligent proof-read-
ing. Finally, special thanks go to The Canada Council
(Special Project Assistance: Publication Assistance) and
The Ontario Arts Council (Visual Arts) for their gener-
ous assistance in obtaining funding for this book.

<div align="right">

Bruce Grenville
Series Editor

</div>

# Acknowledgements

I wish to thank Bruce Grenville for conceiving this project and seeing it through; YYZ for sponsoring it; and Bruce Mau for so ably and elegantly designing the book. Much of the work published here was undertaken with the generous support of The Canada Council and the Ontario Arts Council. Amongst those who have offered me support as a critic, I would like to signal the essential role of Shelagh Alexander — where there is clarity, it is owed to her.

P.M.

# Introduction

To write is to incur debts. But to make this introduction a reading of my writing and not a history of writing-having-read (Bataille, Derrida, etc.) is to project a trajectory where these names in the texts punctuate a conceptual strategy and critical structure. My overarching intent here is not to provide a content or continuity to these essays, let alone a justification, so much as to display certain moves, which is to say criticism is always an issue of displacement. The choice of articles reflects those in which moves took place. These articles are primarily critical, theoretical as we used to say, rather than expository or descriptive. Yet the structure of the book indicates a change of tactics: the articles in Parts I and II literally displace each other's positions; while those reprinted in Part III attempt to develop a pertinent project from article to article.

What is "outside" the texts gathered here is a beginning — an orientation that marks a stance and sets the writing, initially, against the work of art (in the form of a critique), and sends it off on its own, as a drift from art in an excess of writing: an exit. This set-up reacted against

the positional logic, in viewing or interpretation, the one mirroring the other, of the spectator in front of the image/work and of writing as secondary commentary to the full presence of the work of art. Formed initially on Derrida's critique of presence and Adorno's principle of nonidentity, this critique of identity (and structure) led to a contract between writing and viewer against the work (as its exclusions), each of which was to become performative (against its exclusions). The position of the viewer coming to speech became the model for criticism. Hence the concentration on "effect," on the "body" and "speech," and on the demand for a "content" that issued from this fissure of structure. Hence an enactment in *Peripheral Drift* and the articles "The Death of Structure," "Terminal Gallery," "Reading and Representation in Political Art" of the language of "eccentricity and difference," and of a concept of criticism verging on iconoclasm and opening to a recognition of the violence of the critical act. These articles and effects, then, pre-figure the essays from 1980 that begin this collection.

If "Exits" condenses this history, even to the spacings of its writings, "Violence and Representation" provides a return: exit and return through a renewed convention of representation. With a shift of terms from "content" to "representation," a passage is made from a critique of representation to its valuation. Violence unexpectedly played a role. Both René Girard and Georges Bataille forced a recognition of the mutual grounding of violence and representation in each other as a means of realizing rep-

resentation's necessary social nature and "activist" (in Bataille's words "contagious") qualities. Representation can lead to action, "action" understood as an inducement of the excluded viewer to the social register. On the analogy of the individual magnified to the level of the "crowd," this potential of representation fulfils itself in a public "iconoclasm" — a type of critique — directed against the images and spectacles presented to it by capitalism. Since every spectacle implies a specific political formation, representation has a political dimension. And since struggles with the image is also a struggle *over* the image, this project saw its continuation in the articles "Notes on the Sumptuary Destruction of Leaders" and "Image of the Leader, Function of the Widow," which, however, are not reprinted here.

If the occasional essays "Exits," "Violence and Representation" and "Breach of Promise" are "examples" of a fictional facing or speculative arrest before the work of art, they were, all the same, turnings in my writing that underlie all my other criticism. The contemporaneous theoretical articles of the section "From Drift to Dialogue" chart their same passage.

That subtitle, "From Drift to Dialogue," indicates a narrative from Barthes to Bakhtin channelled through Bataille's excess, Lyotard's "death instinct," Deleuze's machinic set-ups, and Austin's speech acts. The critique of identity passing through the issue of content arrives at a more formalized study of representation ("Language and Representation"). That formalism, however, is bifurcated

on every level. *Value* resides in the validation of a local practice; it also calls for the type of critique acted out in "Editorials." That is, on the one hand, concern for the role of the viewer on the part of criticism ends in attention to the nuances of representation; on the other hand, critical license pursues a path that culminates contradictorily in the demand for "work at its word." Representation carried over to the local resulted, as well, in research on reference and reception, terms under which a preliminary history of contemporary Canadian art was attempted. Against all the evidence of the critique of the referential fallacy and the "structural revolution of value," reference was seen to be a means of relay of work and audience to some sort of real social dimension.

This book opens with essays from 1980, a year that marked the intersection of a double "crisis." One was the problematic play between art and criticism: the exit from art. The other was a recognition of the unequal exchange of an art community on the edge of the discourse of power, on the periphery of its reception, in other words, the crisis of a culture of reception. This second "crisis" did not immediately announce itself; instead it worked itself through other demands. Theoretical "intensities" operate on different registers and move along trajectories at different speeds. No more is this true than in the conflict in one body of writing between the theoretical and so-called "non-theoretical," the latter which was to become the basis for a local history. "Crisis" operated as a code word to indicate a lack: the lack of a history of contemporary

Canadian art. As a recurring *structure*, this lack was to be articulated in the very real terms of crises of socio-economic cycles (Mandelian and Innisian) in which Canada was very particularly set. A *local* history was to be constructed, but it could be constructed only under certain constraints which were the conditions of our history. I labelled these conditions the "semiotics of reception." "Colony, Commodity and Copyright" set the direction, which was followed through in "Editorials" and "Axes of Difference," even though these articles addressed other issues as well. While being a culture of reception, Canada was so positioned historically that the negative features of reception allowed a positive comprehension of the economic conditions of late capitalism and the semiotic conditions of postmodernism. We could treat both a logic and a history; but since this history is a lack, semiotics partakes of a symptomology. This lack is registered through its symptoms: its images. Hence a shift of attention from the *language* structuring of the institution of art (for example, in "Editorials" and elsewhere) to the *image* under the conditions of ideology and communication ("Subjects in Pictures").

Curating called a halt, both to these projects and temporarily to my practice as a critic. With that shift of practice, the object itself is changed. If curating, however, could be seen to be a type of writing, a writing with objects, then one has the concrete means to demonstrate that history which is lacking. But it is not simply a matter of the presentation of objects. What became an interrogation

in my writing, complementary to this history, can be seen in curating to be this: the practice of the (re)constitution of the *event*.

Philip Monk

*Struggles with the Image*

I

This essay first appeared in *Impulse* magazine, Vol. 8, No. 3 (Summer 1980), pp. 29-31.

# Exits

Everything follows from this principle: that the lover
is not to be reduced to a simple symptomal subject, but
rather that we hear in his voice what is 'unreal,' i.e.,
intractable. Whence the choice of a 'dramatic' method
which renounces examples and rests on the single action
of a primary language (no metalanguage). The descrip-
tion of the lover's discourse has been replaced by its
simulation, and to that discourse has been restored its
fundamental person, the *I*, in order to stage an utter-
ance, not an analysis. What is proposed, then, is a por-
trait — but not a psychological portrait; instead, a
structural one which offers the reader a discursive site:
the site of someone speaking within himself, *amorously*,
confronting the other (the loved object), who does
not speak.

Roland Barthes, *A Lover's Discourse*

Like a severed worm, she shook overtaken by breath-
ing spasms. I bent over her and had to rip away the black
velvet mask she was choking down and tearing with her

teeth. The disorder of these movements had bared her up to her bush: her nudity now was an absence of sense, and at the same time the excess meaning of a death shroud. Madame Edwarda's silence was strange and anxious: her suffering no longer communicable. I absorbed myself in this lack, in this night of the heart no less solitary, no less hostile than the empty sky. Her body flopping like a fish, the vile rage expressed by her wretched face hardened the life in me, shattered it in disgust.

Georges Bataille, *Madame Edwarda*

*What passes between these two texts, yoked together in some perverse act? One, Barthes' notice ("How this book is constructed") to* A Lover's Discourse; *the other, a translation from Bataille's* Madame Edwarda. *One speaks "amorously," the other violently; or, rather, Barthes speaks rhetorically of the amorous, while Bataille effects a violent speech.*

*To bring them into relay, to make one act through the other; to let one reading decompose the other.*

*Each is an interior speech, structured confronting an other who does not speak. The lover in Barthes, the narrator in Bataille, each may speak obsessively to himself, but the other (the lover; Madame Edwarda) does not reply. So it is with the text. It only "speaks" to me in my desire if it undoes me, decomposes me in my reading. I perform the text in my desire: the text makes me a dissolute reader.*

## Reading and Forgetting

Why Bataille? What does he mean for me? What violence of opposition and mutual decomposition of art and self is marked here in my interest? Why do I seek this thrill, this loss, this spectacle of myself?

I present myself to a text (or a painting, a photograph, etc.) before it presents anything to me. I station myself in front of a text as a "body" of meaning, a unity of sense — a subject, in short. Yet, face to face, the text does not respond, answer my demands: I face an absence when I expected something — a subject, a meaning, a whole.

Facing this silence, as I face a fear, the language of my resistance hardens. Facing this lack of response, I am brought to speech. At any one moment, my language is marked by the difference in forces between the text and my speech. But the text acts upon me: I am bound by its limits. Resisting, I begin to register its

## In the Margins of the Text

*Barthes' writing is a disguised text. To the moral or radical reader (the indignant reader), it is merely indulgent, the decadence of bourgeois ideology, consumed with its own pleasure rather than committed to some cause. A flaccid, not strident writing. A perversely self-styled anachronist (i.e., amateur), while fellow traveller of the avant-garde (the drifting rear guard of the avant-garde), Barthes concedes that "In fact, today, there is no language site outside bourgeois ideology: our language comes from it, returns to it, remains closed up in it. The only possible rejoinder is neither confrontation nor destruction, but only theft: fragment the old text of culture, science, literature, and change its features according to formulae of disguise, as*

restraints. It discharges its language through mine.

In the return of the text upon itself in my reading, a space is crossed. Worked upon by the text, this split between text and reader is re-created in my self, as a shudder, the self falling away from itself. (What is the self but a network of impulses, an incoherence of already-spoken languages that sometimes encode an impulse?) In this moment and movement of the split, language distends; my subject dissolves. Impulses and intermittent desires fluctuate in this gap in rhythmic pulsation. Inscribed by the intensity of the work, I am now a sign of it.

Here then is an invitation to lose ourselves without forethought, without counterpart, without salvation. Is it sincere?...for after all, M. Bataille writes, occupies a position at the Bibliothèque Nationale, reads, makes love, eats.
Sartre, *Situations I*

Bataille brings me to his register

*one disguises stolen goods." Thus the lover who cannot be "reduced to a simple symptomal subject," but can only be positioned in language, as an excess of language — as the intractable unreal.*

*A critical discourse is disguised; in other words: Barthes is tactful, he wears his learning lightly. Or, rather, his text is of another order, but not subservient; it "renounces examples and rests on the single action of a primary language (no metalanguage)." If it drifts from its object (as criticism it should be anchored) in its own affirmation, it becomes fiction. "Fiction would proceed from a new intellectual art... With intellectual things, we produce simultaneously theory, critical combat, and pleasure; we subject the object of knowledge and discussion — as in any art — no longer to an instance of truth, but to a consideration of effects."*

of intensity in my reading, disturbing my approach to and control of the text, even disturbing me physically. He makes my critical abandon into a spectacle, an excess, and exceeding of the text: it goes beyond bounds, is undecorous, unseemly. His strategy deposes me of any use I had for his writing. I am both inside and outside it, an intensive flow out of control. Finally, in a decisive moment, I will this excessive force for myself, appropriate it. At that moment Bataille forces me beyond my fascination with his fetish text, to abandon and forget it in its symbolic convulsions.

He has communicated an effect. For Bataille, the nudity of Mme. Edwarda is an absence of sense; but for the man facing this lack, it still has the excessive meaning of death. He shall remain enthralled if he continues to face it. What Mme. Edwarda finally signals to the narrator is the effect of her abandon. He too hardens and shatters in an orgasm of disgust. Elsewhere in Bataille, urine and blood, vomit

*What is found in the lover is offered to the writer. It is an "utterance, not an analysis," an effective voice.*

*What a prodigious labour of language, or is it an infinite play? I can imagine Barthes, like an old mole hungering for meaning. But he is only cruising. What is meaning to him in the "plurality of entrances, the opening of networks, the infinity of languages" that constitute his texts? They cannot be overtaken by meaning — they shift, or drift, indifferently. There is a tactic of meaning, but it is continually displaced: "It is necessary to posit a paradigm in order to produce a meaning and then be able to divert it, to alter it." But this doubling, drifting and fictional commentary always positions itself with regard to the other, in front of the other, like the lover confronting the loved one who does not*

and sperm serve this same loss as the body is put into flow. Bataille leads us to a point where we remain in disgust, or exit laughing: shattered by laughter, dissolved into the indifferent impulses that return us to Barthes' drift.

> M. Bataille professes to wish only to consider in the world that which is vilest, most discouraging, and most corrupted, and he invites man, *so as to avoid making himself useful for anything specific,* 'to run absurdly with *him* — toward some haunted provincial house, more depraved, ranker than barber shops.'
>
> André Breton,
> *Second Surrealist Manifesto*

*speak. This is no opposition or identity which would produce a meaning. For Barthes, the body is a third term supplementing binary oppositions; it positions itself only to drift. In this discursive site of oscillation that is the neutral, Barthes slipped his body. He spoke to us amorously in the body of his writing.*

*Of his fear, he was hesitant. Only fragments remain: "Bataille, after all, affects me little enough: what have I to do with laughter, devotion, poetry, violence? What have I to say about 'the sacred,' about 'the impossible'? Yet no sooner do I make all this (alien) language coincide with that disturbance in myself that I call* fear *than Bataille conquers me all over again: then everything he* inscribes *describes* me: it sticks."

This essay first appeared in *Impulse* magazine, Vol. 8, No. 4 (Autumn 1980), pp. 34-35. Reprinted in *ZG* magazine, No. 2 (1981), p. 3.

# Violence and Representation

## Representation as Surrogate Victimage

During the early years of pop art, Andy Warhol took newspaper photographs of violence and icons of movie stars as subjects for his silkscreen paintings. There were car crashes, race riots, suicides, and electric chairs, caught in the casual indifference of newspaper print, and at the same time, as if by contrast, the calm, hieratic close-ups of Marilyn Monroe and Elizabeth Taylor. The conjunction shows more than mass fascination with these two types of media imagery. More than an opposition, there is an essential tie between representations of disasters and icons. (The middle term between disaster and icon, condensed in Warhol's paintings of Jackie Kennedy after the assassination of John Kennedy, shows that death can be represented only as the catastrophic, and its violence displaced by the iconic.)

Whether we are engaged in reading an image of disaster or an icon, the impulses are the same. One image does not serve to attract and the other to repel. Against our expectation, we find a covert attraction to disaster as well as a violent reaction to an image of beauty. The chaos of violence finds ambivalent response in the formalized expression of the icon. Violence is not only attracted to the iconic; violence directs representation.

Once recorded, human violence is perceived and dealt with collectively, as a representation. Violence is not simply a disruption within the orderly; it is a mediated effect; it is not passively received, but actively produced by artist and spectator within representation.

In our daily lives, we usually see violence in a representation — in movies, on television. Or we "witness" it on television news or in newspaper photographs, filtered through recording devices. In movies and television, violence is ordered and introduced by the plot; in the news, by written or verbal commentary.

A newspaper photograph, presumably, is a primary "unmediated" representation of violence. Scanned by a matrix of dots and reduced to the indifferentiation of the newspaper page, the image and its meaning must be secured by a caption. This lack of clarity in the reproductive process, its noisy indistinctness, reflects the reduction of difference (and hence the possibility of meaning) that violence introduces into the orderly.

Before representation (if that truly exists), violence is unarticulated; it is without limit. Society orders itself and functions by differentiating, by establishing the limits of inside and outside. Consequently, a limit has to be set to violence which seems a forceful entry of chaos into the order of society; and that limit is a representation — a substitution of one mark for another: the mark of representation for the mark of violence. A community uses violence, creates an economy of violence, to mark limits. And if the raw newspaper photograph, while signalling vio-

lence, cannot adequately effect it, in a failure to cathect the reader, then violence must be directed to where it helps construct another image.

———

While violence may help the artist form an image, it also structures the viewer's response to an image. Violence may be most apparent in a hieratic face or figure — an icon; in front of such depictions, a scene of violent rivalry is enacted.

In an image, an artist imitates a figure; in front of that image, the viewer imitates the artist, but mirrors the image, i.e., imitates it. René Girard describes the violence that arises through mimetic or imitative rivalry: "If one individual imitates another when the latter appropriates some object, the result cannot fail to be rivalry or conflict. Such conflict is observable in animals; beyond a certain intensity of rivalry the antagonists tend to lose sight of their common object and focus on each other, engaging in so-called prestige rivalry. In human beings, the process rapidly tends toward interminable revenge, which should be defined in mimetic or imitative terms." Rivalry is a result of imitation; and mimesis derives from theft.

Girard, in his *Violence and the Sacred*, sees the origin of society and all cultural forms in murder. Recoiling from this original divisive violence, a community creates a set of prohibitions which includes a mechanism for redirecting violence outside itself. This is the role of sacrifice based on the substitution of a scapegoat. Repeated in ritual and

communal crises, this arbitrary substitution protects the community by deflecting internal violence to victims outside itself or on its margins, victims unable to be revenged.

Emulation become rivalry, when one appropriates the object or desires of an other, leads to conflict which spreads through the community. To end this interminable revenge, representing eye for eye and tooth for tooth, is the function of the scapegoat, because the scapegoat cannot be revenged.

The scapegoat must resemble the person it substitutes (which it represents) in order that the violent and vengeful impulse be satisfied. This is the mimetic function of the scapegoat. But, at the same time, the scapegoat must be different, recognized as different, in order that it not be confused with the original object and continue the chain of vengeance. It must represent the violence that afflicts the community, allowing the community to differentiate by excluding what is different: the violence of the other. Representation is a marking preparing for exclusion. Marking is a stigma, which allows the surrogate victim to be identified as different; it sets the limits of exclusion; and it locates the marks of violence for sacrifice.

––––––

The structure of mimetic rivalry persists in advertising. There is no necessary connection between the advertisement and buying the product — mimesis that leads to purchase, an identification between seeing and having the object. Rather, the man or woman in the advertisement

is identified with the sacrificial scapegoat. To prevent a break in the chain of buying because of a disastrous disruption of the system, the mimetic figure substitutes for the internal violence of that system. The violence of production is deflected to an image. Advertising does not direct desire toward consumption as much as create a model that mirrors and reinforces the violent construction of the body through the socialization of work. For any society, we expect to find a relation between the representation of violence, the image of the body, and social control of the body.

Two desires on the same object — the advertising figure's, which signals the desirability of a product, and the reader's — lead to mimetic rivalry. This may ensure capitalist competition, but it ends in violence. To allow that conflict to work (as religion recoiling from original violence developed an economy of violence) and at the same time not to lead to actual violence, capitalism changes its mimetic model, year by year, creating new representations and limits. Mimesis leads to violence, and diffuses violence. Fashion is essentially mimetic, and sacrificial: its figures are marginal and excluded. Society chooses its figures to create its representations and be models, while at the same time violently excluding them. Art, fashion, violence erupt at the margin: the new is the monstrous other.

This essay first appeared in *FILE Megazine*, Vol. 5, No. 3 (Spring 1982), pp. 36-37.

# Breach of Promise

> Death, as we may call that unreality, is the most terrible thing, and to keep and hold fast what is dead demands the greatest force of all.
>
> Hegel

> In effect, nothing is less animal than the fiction, more or less removed from reality, of death.
>
> Bataille

It should be spoken, as if standing in front of a painting, as if in fascination bending forward to capture a detail led to a fall.

It should be spoken, as if a fright rose and lodged itself in the throat, as if death's sex brushed you from behind.

It should be spoken, as if speech could save you from this terror that the eye registers in its primitive state.

A face and head turn, "as if speaking to the other, in rivalry, in anxiety, for recognition."

What is it, what by chance attracts me to these images? What solicits my attention to each and to the pair? Across a gap of centuries, they answer to each other in my atten-

tion. Projected into each other through a correspondence of poses, each is the unconscious of the other, the unspoken. What could not be said in its time is given a history in my encounter.

Why was this choice presented to me, a necessity more than a formal similarity? How do I figure in this choice? What absences signify my presence there more than the unfilled gap in the Michelangelo painting? My presence and absence.

In the presentation of the spectacle, what is offered to me? A gift that is poison. What is offered, a gift that poisons sight. What I do not want to know, what I do not want to face.

Two images beside each other, these images by men, face me. In my position as mediator, what attracts and follows is my complicity as a man — specular and speculative.

The passage from one image to the other, from *The Entombment* to *The Demoiselles*, is a narrative transformation: from the presence of promise to its absence. On my side, the narrative is the representation of fascination — putting its drives into motion. To represent the "breach" between the two images — the breach and the space between — is to register the gap between me and them. Representation leaves an absence in its origin.

The narrative I fabricate at first is compensation for a loss I feel in front of these images. But the movement from one to the other, controlled by the narrative itself, repels my compensation, rejects the insistence of my demands. The narrative is projected as a loss; its history is figured

as a loss. How do I sustain that recognition, the refusal of my compensation?

In its simplest terms, the depiction is a passage from man's nudity to woman's. Behind this nudity is man's absence. (Behind this desire is man's absence.) In both paintings the man is absent, as the presence of a dead body in *The Entombment*, as a complete absence in *The Demoiselles*. With this absence the pictorial agents change. What was once a desire fulfilled in the promise of the body of Christ turns to aggression in the breach of death. Desire turns to aggression in the failure of compensation and symbolic repair. What intervenes between the promise and the breach, between one painting and the other, is man turned to victim in a murder and turned a victim by Picasso's brothel women, Lesbian warriors, Marys become prostitutes.

What is it for the voices of these pictures at that moment? What must be sustained in that reality? In *The Entombment*, the voices circle the absence, which is still there for them in the body, in a grace of acceptance. The voices speak among themselves, disengaged from the viewer who is absent to them. Withdrawn, they make no contact with each other or look to the viewer. In *The Demoiselles*, the women turn aggressively toward the viewer, a man, a customer. (What is man here for the women — a disturbing presence, reminder of promise and its loss? Has grief turned to violence; in animality, the women tear the victim apart? Or is woman's position and antagonistic gaze one of social violence?)

The spectator is not necessary to the Michelangelo

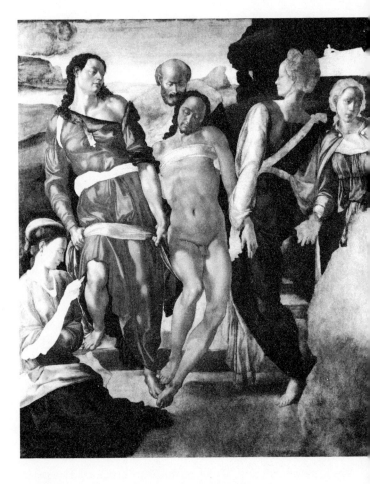

Michelangelo, *The Entombment of Christ* c. 1511.
Tempra and oil on wood, 159 x 149cm.
Reproduced by courtesy of the Trustees,
The National Gallery, London.

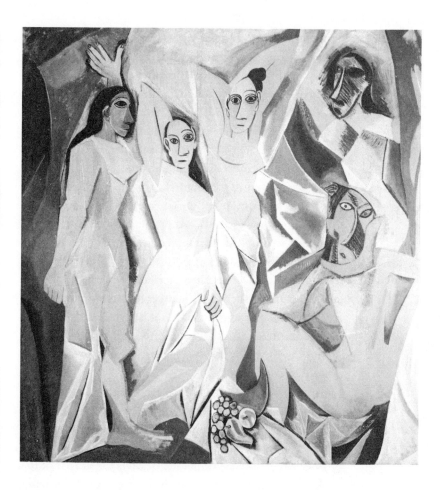

Picasso, *Les Demoiselles d'Avignon* 1907.
Oil on canvas, 244 x 234cm.
Reproduced by courtesy of
the Museum of Modern Art, New York.

painting; although he can observe, he is closed to that drama, discreet and distanced. The man is absent in the Picasso painting, but the spectator is structurally demanded — forcibly excluded by the gazes, but demanded to fill an absent place. How does man return here in his absence? Are the women simply and solely the object of his gaze substituted by the spectator?

Absence at its most invested is abandonment or murder. It is never an empty or neutral figure. Whatever it is, a position is maintained, whether inflected towards absence or another presence. And that absence is simple or mediated — simple as the immediate effects of murder or abandonment — a tearing; mediated, as representation. Recognized absence becomes represented. Recognition is a tableau. But whether the two poles of response to absence are acceptance or aggression, that is, symbolic or actual, representational or violent, the end is representation: the victim torn apart by the women is recreated in absence as a ritual and representation.

But the absence for me reflected in these works, my absence, is not a representation. It is a loss.

The mask plays a role in the look. Representation is a violence of and by the mask.

That which is faced or held in death is the horror of the mask. The violence to the mask is the violence of the mask. The violence of the mask, the violence to the mask is the violence of the mark. Facing me, it calls for my violence to match its own. But for me here in front of this painting, it is not a question of facing or wearing a mask; it is

woman and the mask. Beyond nudity and the mask, nudity and death, it is the mask and *woman's* nudity — my desire and woman's nudity.

Facing and turning. I turn from the spectacle. I avert my gaze. I turn from a conversation. At another time I turn towards a landscape. I turn from the icon, this image, this face.

The icon is opposed to the group, as desire is to civility, as the gaze is to conversation — in a play between violence and civility, between desire and culture. How does civility become violence, turn and transform culture back to nature?

Here the landscape opens; there the icon marks a closure, a limit and marking of my desire.

My figure at that moment of facing is taut, collapsing within, like the tensile arch of the figures supporting the body of Christ, a play between the arch of the bodies and the limpid, dead body. Like a veil, and as the female, the paintings open to reveal the dead object at the base of woman's sex. They open to disclose the male. The male can only be absent. Dead or excluded, he projects himself into that absence in the painting. And he projects himself through the violence of exclusion. What is the object of man's gaze if it is not his own absence? Woman is not the object of his gaze. It is not a single object, but the schema. His gaze is aggressive if excluded, but it is also dissolute and frenzied in a forced absence. In that exclusion, he wishes the immediacy and presence of a violent sexuality, death itself. The gaze is not possessive but destructive: the

other is destroyed as a surrogate for himself. Destruction is figured as the women of *The Demoiselles*, what the man of mastery desires and is not.

The original promise transforms in a binding effect. So as the promise turns, disappears or is spoiled, the recipient turns and is transformed in despair.

The breach of promise is a breaking of the symbolic: the breach strands me in the gap between these two images.

The willed turn in the breach of promise is no compensation. Compensation is a lure and maintenance of the symbolic. "Compensation is a rhythm," she said. And so is art. Beyond compensation, in that indifference, either death or aggression face me. To hold fast what is dead, beyond that promise, is to face that unreality. What is it for the voices at that moment? What must be sustained in that reality, unreality?

# From Drift to Dialogue

## II

This essay first appeared as "Stanley
Brouwn and the Zero Machine"
in *Parachute* magazine, No. 18
(Spring 1980), pp. 18-20.

# The Zero Machine

If Dance in its most innovative instances has insisted on the alteration of the *terms* of discourse, pressed for an altered relationship between performer and audience, decreeing and soliciting new modes of attention and of gratification, this is, in part, because the audience has been, as well, the most problematic element in the dialectic of performance.[1]

Any discourse that alters its terms in relation to the intentional and symbolic structure of the art gallery must confront the problem of its audience. Exclusion from the art gallery and inclusion of the audience are the likely results of this attempt. Discourse exceeds the previously structured domain as a simple displacement or drift: excess as going out; the audience also exceeds a structure reinforcing identity and exchange through interpretative and performative force.

"Interpretation" and the "performative," I think, are the terms of this changed relation, and enunciation the figure of its discourse. "Performative" is the linguistic notion of the *act* of utterance[2] that I have transferred to an *act of the*

"*spectator*"; interpretation (not signification) is the force (or a difference in forces, which also may be the force of a loss) that a spectator brings *to* the work, in relation to it. Both interpretation and the performative, resting with the audience, are outside the search for, or transmission of, meaning; and, consequently, they are a shift and, therefore, a break from the structure of an art that secures the identity of meaning and personal subject, in an exchange brought about between the two through the regulating control of the art gallery.

Criticism, as a form of interpretation, must alter the terms of its discourse, perhaps toward the performative. The object of my interpretation is Stanley Brouwn's *This Way Brouwn*. Interpreting Brouwn's work, I act through a document. What are the assumptions of this act?[3] I only know the documentation, not the "originating" event; then perhaps I should stop at the surface of the documentation, and not attempt to go beyond the document to find its meaning in the support of the work; to find the intention of the work in the document; or to expect the documentation to be a re-presentation of the work. If my interpretation goes beyond the work, it is as a positive speech act and not as a detached and secondary representation of the meaning of the work. Rather than depart from the work, this activity may only constitute its plurality.

The documentation, a book *This Way Brouwn*,[4] consists of German and English text, reproductions of notes and drawings given to Brouwn during the execution of the work in Amsterdam. The English text follows:

Stanley Brouwn has been gathering *This Way Brouwn* answers since 1960. The present series was produced on Dam Place, Amsterdam, on February 25 and 26, 1961.

Brouwn is standing somewhere on the square. He picks at random a pedestrian and asks him to explain on a scrap of paper the way to another point in the town. Another pedestrian explains the same way to Brouwn. The 24th, the 2000th, the 100,000th pedestrian shows Brouwn the way. *This Way Brouwn*.

The pedestrian covers a distance from C to D. The point of departure A of a *This Way Brouwn* A-B is always situated somewhere on the pedestrian's way. In those cases where B is also situated on C-D the *This Way Brouwn* becomes part of the pedestrian's route. In the case of B-A there is no distance to be covered. The paper is likely to remain blank. *No Way Brouwn*.

A *This Way Brouwn* is produced in the time it takes for the pedestrian to give his explanation. No second thoughts, no polishing and touching up the result.

Brouwn's share in the result is in putting the questions. In the presence at point A, in the fusion with point A, in representing point A in the flesh.

People should walk up to Brouwn and ask him: "Where do you want to go, Brouwn?"

There are no good *This Way Brouwns*. There are no bad
*This Way Brouwns*. The result of a *This Way Brouwn* does
not depend on the pedestrian selected. Brouwn does not
select. He picks at random. The fleet of streets, squares,
lanes, etc. is sinking deeper and deeper in a network of
*This Way Brouwns*. All direction is being drained from it.
They are leading nowhere. They are already involved,
captured in my work. I am concentrating the direction
of all possible ways in my work. I am the only way, the
only direction. I have become direction.

People talk while sketching their explanations, and
sometimes they talk more when they draw. On the
sketches we can see what people explained. But we
cannot see whatever they omitted having some diffi-
culty to realize that what they take for granted needs
to be explained.

Looking at *This Way Brouwn* we may imagine numer-
ous other *This Way Brouwns* which might have happened
instead.

The document "indicates" that the work was created in
real time and literal space, created with the interactive par-
ticipation of a public. Contemporary to Happenings and
Fluxus's breakdown of the separation of art and life, it
was not an enactment of the artist's real-time gestures in
front of an audience still treated generally as spectators.
Although similar to the aims of Minimal art (or recent

"spatial art"), it was not particularly concerned with extending the medium of sculpture to include the perceiving and motor human body in real time and literal space. Its "process" did not produce an "object" as occurred in anti-form art; nor was it conceptually objectified, but achieved in *dialogue*: it "is produced in the time that it takes for the pedestrian to give his explanation."

Dialogue is this event, produced in real time and space, between artist and audience. Although dialogue is grounded in community and communicability, Brouwn's work (as witnessed by its conceptual presentation and documentation) only seems to initiate dialogue, not sustain it: "Brouwn's share in the result is in putting the questions." An interpretative and performative activity is demanded of the audience through the initial connection of the question. Dialogue is the communication of enunciation, not meaning, an act, not a transmission.

Although the performative is concerned with the act of utterance and not its content, and although the structure of this dialogue is without an initial content, a content can be brought *to* the work, by the audience, as an act that complements the transfer of responsibility to the audience. The demand opposed to the lack of some type of signification (as an increase in interpretation, as an excess of interpretative force) is similar to that of the archaic and primitive gift exchange analyzed by anthropology.

Marcel Mauss examined the "total social phenomena" of primitive societies in an attempt to uncover the transactions regulating communities not based on the primacy

of economic exchange. He found the gift exchange —
which functions through the obligations to give, receive
and repay — to be the common denominator underly-
ing numerous social activities.[5] The forces operating the
exchange, such as *hau* (the spirit which obligates), promote
an increase in non-economic value: honour, prestige, posi-
tion; and these values, exceeding the economic structure,
are a type of content beyond exchange. The exchange
operates as a dialogue, as a means of communication and
integration; but it also allows something to exceed its reg-
ulating economy, that in my analysis is the interpretative
force of response.

The necessity to motivate the gift exchange outside the
utility of economics by the obligations to give, receive and
repay was reinterpreted by Claude Lévi-Strauss as the
necessity of the unconscious *structure of the exchange* itself.
The three obligations, as production in excess or as sur-
plus value of code, were reduced by Lévi-Strauss to a
superstructural affect determined by the unconscious struc-
ture of exchange that is based on language. To explain the
"supplement" of signification of notions like *hau* and *mana*,
Lévi-Strauss conjectured a "zero symbolic value," based
on the linguistic hypothesis of the zero phoneme, and
whose function "is to be opposed to the absence of signi-
fication without entailing by itself any particular signifi-
cation."[6] I think that the dialogue in Brouwn functions as
a zero symbolic value (with some reservations to be dis-
cussed below), effecting itself in relation to an exterior,
the public which brings an interpretative force to it.

The dialogical mechanism, as common as the practice of conversation, may be assumed, i.e., taken over, by the public, and, once assumed, "communicated." If "the result of a *This Way Brouwn* does not depend on the pedestrian selected," nor on the artist who only picks at random and puts the question, then anyone is able to engage in dialogical practice, and, indeed, to start it: "People should walk up to Brouwn and ask him: 'Where do you want to go, Brouwn?' "

As much as dialogue integrates, the mechanism can also be a potential analyzer, since it constructs by connecting with the interpretative force of the spectator/public, a force that combines desire and content. Compare the function of the theoretical mechanisms of psychoanalysis in relation to the subject's history and desire: they explain an operation of desire and its repression, but also function in relation to a subject as analysand.[7] The dialogical mechanism has that same relational value. Desire and content, as interpretative force, must be considered together (while pulsionally unbound) in the same performative utterance, and, consequently, outside of ideological determination in their production. And that is why we cannot avoid content or naming desire.

In my interpretation of the Brouwn document, dialogue is not structured as knowledge or meaning; not as ideology, but as content/desire, although it is manifested within ideological formations. When Brouwn observes: "On the sketches we can see what people explained [when Brouwn asked directions in the street]. But we cannot see

whatever they omitted having some difficulty to realize that what they take for granted needs to be explained," we might attribute this to the need for ideological analysis. What the pedestrians omitted is assumed by the common ground of understanding but it still needs to be explained, either by interpretation or further dialogue. Or to make up for what is left unsaid, we must also engage in ideological analysis, since what is omitted is often assumed as natural, whereas it is part of the history of the community. Instead of presuming an ideological analysis of a structural meaning, perhaps we should pay attention to what is produced — the enunciation, which may precede the description of a content as meaning, and call into question the individual subject.

[In abandoning an ideological analysis, I have to question my use of Lévi-Strauss's structure, since, for him, interpretative force would be only a superstructural affect. As much as Lévi-Strauss's analysis gives us a structural understanding of the mechanism in Brouwn's document, does it not repress that mechanism in an equalized exchange that forbids the supplement of content; and reduce dialogue, "in conformity with the initial relational character" of dialogue, to a static and closed exchange of oppositions as equivalents, whereby each speaker is restricted to this form and identity? Does it not reduce the unconscious to an empty form where even desire is absent? Desire and content are extrinsic to the immanent field of his analysis — the illusional superstructure in conformity with the "real" structure of the unconscious. But what is the imm-

anent field, what composes that field but the mechanism in production — an engaged machine rather than an empty structure, a machine that refuses the inside/outside, structure/superstructure dichotomy?[8] Desire is a production of this immanence, whereas in Lévi-Strauss it is subsumed by the structure (the immanent field for Lévi-Strauss is structured rather than produced), as a mere form of ideology — an affect rather than effect.]

I wrote above: "the document 'indicates;'" yet that was speaking *through* (beyond) the (transparent) document, and *through* critical and historical knowledge. In fact, I have a document presented to me in/as this book, beyond the artist's presence. It would be misleading to confuse my relation to the document with that of a participant in the event; but in a conscious working through,[9] that is, in a relation of practice, in my reading and participant's activity, a similar interpretative act ensues. As many times as Brouwn's name appears in the document and as much as he seems to arrogate the activity to himself ("I am the only way"), an "author" is absent in the text. In the artist's similar withdrawal into anonymity in the event — "Brouwn does not select. He picks at random"; "Brouwn's share of the result is in putting the questions" — the subject-object relationship disappears — the relationship where the subject represents the spectator or the spectator is the subject to the art object. Following that disappearance is the undoing of my subjecthood, the loss of my identity in interpreting this document. My engagement with the text/work promotes this loss of identity as a con-

stituted subject reinforced by the structures of society, the art gallery, criticism and art history, and meaning. The loss is not passive, but an active *operation*, an interpretation undoing my subject in following the operations of the text/work, in my struggle with it, in an assumption of its mechanisms that go beyond my individual subject toward collective enunciation. It is an operation common in the French theory of the Text:

> *Significance* (sic) is a *process* in the course of which the "subject" of the text, escaping the logic of the *ego-cogito* and engaging in other logics (of the signifier, of contradiction), struggles with meaning and is deconstructed ("lost"); *significance* — and this is what immediately distinguishes it from signification is thus precisely a work: not the work by which the (intact and interior) subject might try to master the language (as, for example, by a work of style), but that radical work (leaving nothing intact) through which the subject explores — entering, not observing — how the language works and undoes him or her. *Significance* is "the un-end of possible operations in a given field of language." Contrary to signification, *significance* cannot be reduced, therefore, to communication, representation, expression: it places the subject (of writer, reader) in the text not as a projection...but as a "loss," a "disappearance." Hence its identification with the pleasure of *jouissance*...[10]

While the subject as a spectator and an identity disappears,

a subject, a *speaking subject*, is formed in/as the network of dialogue, as a (multiple) production of interpretation(s).[11] The enunciation produced is not individuated,[12] nor is the content to which it is related subjectivized; both issue as collective. Content and expression, as enunciation, usually are subjected to the use-value of meaning. That is, in communication, there is a definite meaning (content) in a message transmitted, received and understood, and a transparent medium (expression) of that transmission/ exchange that carries the message. In enunciation (in the act of uttering, not in the uttered proposition or statement), the spectator's body removes itself as a transparent receiver of a message (traditionally, in the structure of the work of art, the spectator is a repetition and reproduction of meaning, intention), in order to be inscribed as a material body, as content/desire. Instead of its communicative and representative functions, language here is performative, no longer a transparent carrier but an intense matter/ sign, outside of exchange.

Enunciation as expression may precede content, in order either to prefigure it (expression may precede a new social form) or dissolve its previously rigid forms (Hjelmslevian "forms of content") in a flow, or to make them follow a line of flight or transformation.[13] Content is carried in this issue — asignifying and aformal — as part of the enunciation, inseparable from desire: we have a *"machine of expression* capable of disorganizing both its own forms and forms of content, in order to liberate pure content which confounds with expression in a same intense mat-

ter *(matière intense)*."[14]

Perhaps more than formed, the subject is "set up" in a process of polyvalent and proliferating connections that are immanent and contiguous. There is neither a transcendental subject that guarantees this set-up, nor a transcendental law or Signified that rules the network (and this reading). It is an unlimited field of immanence *("champ d'immanence illimité")* of desire and power. Yet, "the problem: not at all to be free, but to find an issue, or an entry, or a direction, an adjacency, etc.," in a network that is a matter of entries and connections.[15] This network is composed of a collective set-up of enunciation *("agencement collectif d'énonciation")* and a machinic set-up of desire *("agencement machinic de désir")*.[16] That is, an individual participant's enunciation is already collective through the desire with which it is confounded.

There is no separation into levels of representation in this immanent field, only a unity of work, participation, reading and interpretation. Outside of exchange, we are outside of representation (representation of meaning, representation of and for us by the artist), at once subject, object and expression: performative in speech and body.[17] "The fleet of streets, squares, lanes, etc. is sinking deeper and deeper in a network of *This Way Brouwns*." Desire saturates the social field in producing it, and that desire is direction (metonymy or displacement in psychoanalytical theory): "I have become direction." The zones of the body fuse with the social field in this network (metaphor or condensation in psychoanalytical theory): "In the presence at

point A, in fusion with point A, in representing point A in the flesh." A multiplicity of desire is revealed in and as the network: "All direction is being drained from it. They are leading nowhere."

*Notes*

1. Michelson, Annette, "Yvonne Rainer, Part 1: the Dancer and the Dance," *Artforum*, January 1974 (New York).

2. Jacques Derrida describes J.L. Austin's elaboration of the performative as having the following characteristics:

(1) speech acts serve only as the *act* of communication;

(2) it concerns not the transmission of a thought-content, but the communication of an original movement, a production and operation of an effect;

(3) the act does not have a referent outside itself or prior to it. It does not describe but transforms a situation; and,

(4) it is not predicated on the authority of a truth value, but has the value of a force, of the difference of force.

Thus, "the performative is a 'communication' which is not limited strictly to the transference of a semantic content that is already constituted and dominated by an orientation toward truth." Derrida, Jacques, "Signature Événement Contexte," *Marges* (Paris: Éditions de Minuit, 1972), pp. 382-383; translated as "Signature Event Context," *Glyph*, number 1 (Baltimore), pp. 186-187.

3. I owe to Judith Doyle the clarification of the confusion of document and event at points in my text.

4. Brouwn, Stanley, *This Way Brouwn, 25-2-61, 26-2-61,* Zeich-

nungen I (Köln: Verlag Gebr. Köning, 1971).

5. Mauss, Marcel, *The Gift, Forms and Functions of Exchange in Archaic Societies*, trans., Ian Cunnison (New York: Norton, 1967). *Cf.* Bataille, Georges, *La Part maudite precédé de La notion de dépense* (Paris: Éditions de Minuit, 1967); Bataille changes the three obligations — give, receive, repay — to give, lose or destroy.

6. Lévi-Strauss, Claude, "Introduction à l'oeuvre de Marcel Mauss," in Mauss, Marcel, *Sociologie et anthropologie* (Paris: PUF, 1950), p. L. "In the system of symbols constituted by all cosmologies, *mana* would simply be a zero symbolic value, that is to say, a sign marking the necessity of a symbolic content supplementary to that with which the signified is already loaded, but which can take on any value required, provided only that this value still remains part of the available reserve and is not, as phonologists put it, a group term." And in a footnote to this passage, Lévi-Strauss writes: "Linguists have already been led to formulate hypotheses of this type. For example: 'A zero phoneme is opposed to all the other phonemes in French in that it entails no differential characters and no constant phonetic value. On the contrary, the proper function of the zero phoneme is to be opposed to phoneme absence.'" (R. Jakobson and J. Lutz, "Notes on the French Phonemic Pattern," *Word*, no. 2 [August 1949]: 155.) Similarly, if we schematize the conception I am proposing here, it could almost be said that the function of notions like *mana* is to be opposed to the absence of signification, without entailing by itself any particular signification." *Ibid*. Translation from Derrida, Jacques, "Structure, Sign and Play," *Writing and Difference*, trans., Alan Bass (Chicago: University of Chicago Press, 1978), p. 290.

7. "It is certainly this assumption of his history by the subject, in so far as it is constituted by the speech addressed to the other, that

constitutes the ground of the new method that Freud called psycho-analysis...Its means are those of speech, in so far as speech confers a meaning on the functions of the individual; its domain is that of concrete discourse, in so far as this is the field of the transindividual reality of the subject; its operations are those of history, in so far as history constitutes the emergence of truth in the real." Lacan, Jacques, "The Function and Field of Speech and Language in Psychoanalysis," *Écrits*, trans., Alan Sheridan (New York: Norton, 1977), pp. 48-49.

8. Of Lévi-Strauss's structure of the unconscious, Deleuze and Guattari write: "Such a form can serve to define a preconscious, but certainly not the unconscious. For if it is true that the unconscious has no material or content, this is assuredly not because it is an empty form, but rather because it is always and already a functioning machine, a desiring machine..." Deleuze, Gilles, and Guattari, Félix, *Anti-Oedipus, Capitalism and Schizophrenia* (New York: Viking, 1977), p. 186. They also comment on the pathological character of the closed system of prices, and instead examine the primitive economy as a surplus value of code; pp. 149-150.

9. Freud's 1914 essay, "Recollection, Repetition and Working Through," relates the value of "working through" as an attention to the act and text of interpretation.

10. Barthes, Roland, *Image, Music, Text*, trans., Stephen Heath (London: Fontana, 1977), p. 10.

11. *Cf.* Nietzsche: "We have no right to ask *who* it is who interprets. It is interpretation itself, a form of the will to power, which exists (not as a 'being' but as process, a becoming) as passion."

12. "A collective disposition of enunciations will say something about desire without referring it to a subjective individuation, with-

out centering it around a pre-established subject and previously codified meanings." Guattari, Félix, "Everybody Wants to be a Fascist," *Semiotext(e)*, Volume 2, number 3, 1977 (New York), p. 90.

13. "…c'est l'expression qui devance ou avance, c'est elle qui précède les contenus, soit pour préfigurer les formes rigides où ils vont se couler, soit pour les faires filer sur une ligne de fuite ou de transformation." Deleuze, Gilles, and Guattari, Félix, *Kafka, pour un littérature mineure* (Paris: Éditions de Minuit, 1975), pp. 152-153.

14. *Ibid.*, p. 51. Translation mine. *Cf.*, p. 153: "And it is the one and same desire, the one and same set-up which presents itself as a machinic set-up of content and a collective set-up of enunciation."

15. "Which point of entry is of no importance, of no more value than another, no entry has a privilege, even if it is almost a dead-end , a narrow tube, a syphon, etc. One only searches by which other point to connect one's entry, by which cross-roads and corridors one takes in order to connect two points, what is the rhizome's map, and how it immediately modifies itself if one enters by another point. The principle of multiple entries prevents only the introduction of the enemy, the Signifier, and the attempts to interpret a work which, in fact, only proposes experimentation." *Ibid.*, p. 7. Translation mine.

16. *Ibid.*, p. 145. Also p. 147: "No machinic set-up which is not also a social set-up of desire, no social set-up of desire which is not a collective set-up of enunciation."

17. "Collective dispositions of enunciation produce their own means of expression — it could be a special language, a slang, or a return to an old language. For them, working on semiotic flows, or on material and social flows is one and the same thing. Subject and object are no longer face-to-face, with a means of expression in a third position; there is no longer a tripartite division between

the realm of reality, the realm of representation or representativity, and the realm of subjectivity. You have a collective set-up which is, at once, subject, object, and expression. The individual is no longer the universal guarantor of the dominant meanings. Here, everything can participate in enunciation: individuals, as well as zones of the body, semiotic trajectories, or machines that are plugged in on all horizons...An individual statement has no bearing except to the extent that it can enter into conjunction with collective set-ups which already function effectively: for example, which are already engaged in real social struggle.... The individuated enunciation is the prisoner of the dominant meanings. Only a subject-group can manipulate semiotic flows, shatter meanings, open the language to other desires and forge other realities!" Guattari, Félix, "Everybody Wants to be a Fascist," p. 91.

This essay was first presented as a lecture, October 11, 1980, in Montreal at the colloquium "Multi-disciplinary Aspects of Perfor-mance: Postmodernism," sponsored by *Parachute* magazine, and pub-lished as "Coming to Speech: the Role of the Viewer in Performance" in *PERFORMANCE: TEXT(E)S & DOCUMENTS* (Montreal: les édi-tions Parachute), 1981, pp. 145-148.

# Coming to Speech

## The Role of the Viewer in Performance

The calling into question of languages and established codes by performance radically denies convention. Yet, performance together with that broader manifestation called "Postmodernism" have ensured the revival of a number of conventions suppressed in Modernism: genre, allegory, narrative, mimesis. Even Modernism will return as a genre, if it has ever left — not as absolute truth, but as genre convention, representable within the gallery. Perhaps the calling into question of languages and codes multiplies the codes, displays their differences, and puts them into effect. (It is as if we even have to relearn the effects of traditional conventions.) Even in its multiplication, performance potentially establishes itself as a conventional act, an act which may be constructed.

The "postmodernist" return to the art gallery (when there is a return) marks a break both with the gallery's modernist transparency and post-minimalist assault on that transparency. The gallery acknowledges its conventions by accommodating languages, representations or codes in its space. Another convention returns: the viewer. What returns is a new position for the viewer — the position as

operator or performer. The viewer returns not as a unity, but as a rupture, as one voice among the codes.

The space of performance is not necessarily the space of the gallery; but is it a conventional space, a space of representability and communication? Often, the spaces are as peripheral as the acts are disruptive, but the peripheral and disruptive gain meaning as differences, not within a totality of opposition, but as a drift alongside structures and within conventions. The space of performance does not — cannot — escape the intention of a relation to an audience. Audiences conventionalize the acts of communication however we wish to characterize that communication, at this point, as a transmission of meaning or the communication of an effect. Failure to recognize the audience reinforces the traditional role of the ideal spectator in his/her imaginary identity. My concern is the degree of identity or drift the viewer is allowed.

What is a necessity in practice, the audience, becomes a problem in theory. As such, the audience, perhaps more than any other factor, poses the question of the limits of performance. Here are three expressions of this problematic encounter:

What are the limits of performance? We do not know with certainty. For several years we have been aware that performance did not necessarily need an audience. It could be done as an activity, in which the performer was his own audience so to speak.

Michael Kirby

If Dance in its most innovative instances has insisted on the alteration of the *terms* of discourse, pressed for an altered relationship between performer and audience, decreeing and soliciting new modes of attention and gratification, this is, in part, because the audience has been, as well, the most problematic element in the dialectic of performance.

<div align="right">Annette Michelson</div>

The theater of cruelty is not only a spectacle without spectators, it is a speech without listeners.

<div align="right">Jacques Derrida</div>

For all these writers, the audience is unnecessary, problematic or impedimental for performance.[1]

We can sketch three spaces for the audience or viewer: the space of spectating — a locale of idealist or phenomenological identity, still a grid of perspective and representation; the space of reading — the production and reading of signs in semiotics; and the problematic space of what might be called variously transformation, effectuation, inscription, operation, or, simply, performance. If we could define this last space we would understand the role of the audience in performance: arguments on presence and effect concern this question. We could call this last space, performative. The notion of the performative, or speech acts, is useful here because performative utterances can "create or define new forms of behaviour" within the conventional.[2]

Why choose the performative? Is the term "performative's" coincidence with "performance" more than happy? All that the performative utterance entails initially should be thought through if a theory of performance is to base itself on speech acts. A performative utterance is an act of speech, not a report in speech. It transforms a situation and produces an effect: it has a force, not a truth value. For all this talk of the communication of effects, and the value of a force, the notion of the performative and its attendant theoretical discourse hardly seem constrained; but a performative act is still a conventional act; and that is what interests me. For a performative utterance to be successful, or happy, as Austin puts it, there must be a conventional procedure and appropriate circumstances and participants. For an example of the performative utterance, Austin uses the promise of which he states: "It is obviously necessary that to have promised I must normally (A) have been *heard* by someone, perhaps the promisee; (B) have been understood by him as promising."[3] This points to the conventional nature of the code; the role of the addressee (being heard); and the chain of communication (being understood). A context is built as much as it is broken in the multiplication of codes in performance.

Just as performance makes demands on a viewer, so the performative utterance needs an addressee to be successful. The viewer is conventionally demanded. What the performative offers, then, is useful because: (1) it conventionalizes, but allows for an effect; (2) it necessitates an audience, whose understanding is part of the act, an under-

standing which (3) is not semantic but effective: something is transformed;[4] (4) the relation between performer and audience is not on the order of an intention, but a promise (the performative is founded on the study of the promise, whereas semiotics is founded on the possibility of the lie);[5] and, (5) the first person present indicative active utterance demands a transfer of responsibility to the audience: the viewer is "performative."

If the viewer comes to speech — which is not the same as participation — by becoming performative in interpretation, then he or she is no longer in a position of transparent identification with the work, nor secondary to it as, for example, a critical commentary is presumed to be. The viewer is not only necessary, but affirmed, in performance. This affirmation, however, is first a doubling and exceeding of the space of performance; performance disrupts the viewer's normal structural position in the event of art.

How has a "speaking subject" entered art and our discourse? At a point, body and language entered art very specifically. This disruption — at first formal — could not escape a slide to the body and speech of the viewer. The entry is not a twentieth century history of performance that I might cite, but the introduction of the perceiving and motile body in minimal art. Is performance, as a manifestation of speech and body, a structural development from minimalism and the further intrusion of language and body in subsequent conceptual and body art, or is it a rupture? My contention is that it is a rupture, and a rupture

that is contingent on the viewer. In deciding on which side of this rupture a work lies, my question is: what space for interpretation does the work allow? Once again, it is a question of identity or drift for the viewer: what identification(s) does the work make; what movements does it compel?

Minimalism resists language; yet, language underlies, structures, and brings it into meaning in its presence within a suppressed context. It is temporality, brought about by the introduction of the body in minimal art, not language and hence interpretation by the viewer, that is thought to allow the possibility of the viewer's active participation. While being a condition for interpretation, temporality in minimalism — as a repetition of the *form* of a presence — is merely another means to bring the viewer into identity with the work through a process that reduces the viewer to the same apodicticity — positivity, immediacy and certitude — as the object, a process of reduction to the transparent sign articulated on one level only.[6] There is no gap for interpretation that the viewer brings to the work. Similarly, body art, in its continuing stubborn assertion of the presence of intention and body cannot assist performance in the questioning of languages and codes since the single level of articulation of presence simply does not acknowledge them. This points to a fundamental difference between performance and body art, as body art is a pure inscription in presence on a non-signifying body, although its documentation in photographs may disturb that intention. Documentation as index displaces the value

of form and presence. Documentation leads to reproduction and distribution, which in turn question both an original object (through reproduction) and an original site (through distribution). Pursued in themselves, we have supplantation, not supplementation, by documents. Rosalind Krauss, on the contrary, wrote that "This logic [of the index] involves the reduction of the conventional sign to a trace, which then produces the need for a supplemental discourse." The supplementary discourse, however, must become a disjunctive one, not just a dissension, but a distension, a critique of structure and its displacement at the same time — a disarticulation by the discursive drift of the viewer. For Krauss, it is still a question of the maintenance of presence: the index "operates to substitute the registration of sheer physical presence for the more highly articulated language of aesthetic convention."[7]

We also should not think that this direction toward language implicates conceptual art in an opening to the viewer. The same formal and intentional conditions that structure minimal art form the structure of conceptual art. When language is skimmed off the object, we find conceptual art. The formal structure of minimalism subsists, framed in its self-referentiality through the strategies of declaration by tautology, intention or context.[8]

Another coming to language of structure, but not necessarily an excess of structure, manifested itself as ideological critique, and was a development from context-oriented conceptual art in its encounter with Marxism and semiotics. But how often do these museological investigations

remain formal and structural indices of the museum, however critical they may be? A speech that exceeded structure rarely took place. Oriented toward ideology and therefore to representations and language, what was forgotten was the relation to an audience; what exceeds structure as speech necessarily must situate itself in relation to an audience and address it. Instances of direct speech must be examined in their space of speech — the literal space of engagement, and in the spacing speech develops in the viewer. This direct speech may be considered as monological or dialogical, to borrow Mikhail Bakhtin's terms.[9]

If the performative performance is an effect, it calls for more than a recognition of signs, unless its effective production be to make the viewer a sign of the work. While performance allows the viewer to recognize the social image or construction of his or her body, it is not simply a "spacing out" of the sign — a temporalizing and spatializing of the sign through the agency of the body of the performer open to the sight of the viewer. Performance permits the body of the *viewer* to be field, image and tender within the act of communication, and to escape mere reception or registration by the rechannelling of the "message" through "spontaneous" and excessive behaviour (speaking of interpretation, not intervention in the performance), which is the production of a critical effect: that is its "performative" role.[10] It is appropriate, since social control represents itself simultaneously in both our speech and bodies, that that which escapes in the speech and body of the receiver of performance should concern all of us

who are positioned within societal codes, and *who position ourselves* in the space of performance.

Intention in performance is not directed to a presentation of simple and transparent meaning and communication to the transmission of a semantic content. To displace the suspicion that performance leads to a fulfilment of a transparent presence and identity, I shall sketch this space. We have the body and speech of the performer acting in and across a space toward another body that is the viewer. The viewer is not a position at a point outside the space (a classical view), nor is the viewer a passive observer within this space. A space is created in the passage to the viewer. At the same time this spacing doubles its effect as a "spacing" of the viewer. The viewer comes into identity with the performance; but this inscribed identity opens to a discursive space between two "marks" on the "body" of the viewer — what the viewer brings to the performance as knowledge, desire and history (ideology) and how the viewer is acted upon by the analytical effects of the performance. The opening between the marks, become non-identical, operates as a difference in forces (which may be the force of a loss); and in this gap, the viewer supplies content as an issue. Produced by the performance, dissolution is carried out by the viewer. As much as the viewer makes the spacing of performance — realizes its codes, he or she fully realizes it in himself/herself.[11]

I am describing what happens during and what comes after the artist's performative act — a completing of the act by the active viewer, and a carrying away, an exceed-

ing doubling: indifferent, in-difference.[12] This is no secure discourse where both subjects are present to themselves. Speech directed toward an other (performer to viewer) brings that subject to crisis.[13] "Infelicities," which can make a performative utterance unhappy for Austin, can work to produce a drift or crisis within the identical.[14] Infelicities work through the viewer as a delay, difficulty or resistance, and serve to let the particular analysis of a performance come to completion in the "speech" of the viewer.

*Notes*

1. Kirby, Michael, quoted in Bruce Barber, "Indexing: Conditionalism and Its Heretical Equivalents," AA Bronson and Peggy Gale, eds., *Performance by Artists*, (Toronto: Art Metropole, 1979), p. 191; Michelson, Annette, "Yvonne Rainer, Part 1: the Dancer and the Dance," *Artforum*, January 1974; Derrida, Jacques, "The Theater of Cruelty and the Closure of Representation," *Writing and Difference*, trans., Alan Bass, (Chicago: University of Chicago Press, 1978), p. 332.

I introduce Derrida both because of the influence of his writing (particularly his writing on Artaud) on theories of performance, and because he has made a critique of Austin's performative, whose ideas similarly form the basis of an elaborating theory of performance. See Jacques Derrida, "Signature Event Context," *Glyph* (1977), pp. 172-197, a translation of "Signature Événement Contexte," *Marges* (Paris: Éditions de Minuit, 1972), pp. 365-393.

2. Searle, John R., *Speech Acts*, (Cambridge: Cambridge Univer-

sity Press, 1969), p. 33.

3. Austin, J.L. *How to Do Things with Words*, (Cambridge, Mass.: Harvard University Press, 1975), p. 22.

"(A.1) There must exist an accepted conventional procedure having a certain conventional effect, that procedure to include the uttering of certain words by certain persons in certain circumstances, and further, (A.2) the particular persons and circumstances in a given case must be appropriate for the invocation of the particular processes invoked. (B.1) The procedure must be executed by all participants both correctly and (B.2) completely." *Ibid.*, pp. 14-15.

Derrida opposes "writing" in its "iterability" — as outside context and the necessity of a receiver — to Austin's speech acts which conventionally demand them.

4. Speech acts may be illocutionary or perlocutionary: both have a force value. In the illocutionary utterance, we recognize the intention to produce an effect, such as warning, ordering, advising, etc. In the perlocutionary utterance, there is an actual effect, such as in convincing, persuading, scaring, alarming, deterring, etc.

5. "In the case of promising — for example 'I promise to be there tomorrow' — it's very easy to think that the utterance is simply the outward and visible (that is, verbal) sign of the performance of some inward spiritual act of promising." The word of promise is that act. When I promise I actually do promise, commit myself to that act; although I might be insincere about keeping that promise, I have still made the act of promising. Austin, "Performative Utterances," *Philosophical Papers*, (London: Oxford University Press, 1970), p. 236.

6. For the relationship of form and presence, see Derrida, Jacques, "Form and Meaning," in *Speech and Phenomena*, trans. David B. Allison, (Evanston: Northwestern University Press, 1973). Cf. Michel-

son, Annette, "Art and the Structural Perspective," in *On the Future of Art*, (New York: Viking, 1970), pp. 51-56.

7. Krauss, Rosalind, "Notes on the Index: Seventies Art in America," *October*, number 4 (Fall 1977), p. 59; number 3 (Spring 1977), p. 81.

8. I exclude, for example, Lawrence Weiner who in his work seems concerned with conditions of existence and receivership: "My own art never gives directions, only states the work as an accomplished fact:

> The artist may construct the piece;
>
> the piece may be fabricated;
>
> the piece need not be built.
>
> Each being equal and consistent
>
> with the intent of the artist
>
> the decision as to condition
>
> rests with the receiver upon the
>
> occasion of receivership"

His work does not impose a single condition for receiving it; it is dependent on the receiver for how it is accepted and transformed. "When you deal with a piece of mine, you come across it as a sentence. It's just verbal...You look at it, and you place it within the context of art..." It is a dialogical activity, an acting by the viewer/receiver within the conventions of art: "Whether or not it does make sense to you, you try to construct it within the context of what you know as art." Weiner, Lawrence, in Ursula Meyer, ed., *Conceptual Art*, (New York: Dutton, 1972), p. 218; *Avalanche*, (Spring 1972), p. 68.

9. Some monological examples: Joseph Beuys' direct speech is put in doubt by his practice and theory of meaning. Hans Haacke's polling of spectators at the 1970 MOMA *Information* exhibition and his

questionnaires at the John Weber Gallery in 1972 and 1973 allowed the audience to come to speech; but this speech was structured as referendum. The direction toward an other, the integral other of the audience, radically alters the position of the work of art, and the artist or performer. It was announced by Bakhtin as a direction toward the word of an other, a first person utterance directed toward the speech of an other, Bakhtin, Mikhail, *Problems of Dostoevsky's Poetics*, trans. R.W. Rostel, (Ann Arbor: Ardis, 1973). The dialogical novel sets up a "plurality of equal consciousnesses and their worlds" (p. 4) and dialogizes the relationship not only between the characters, but between characters and author, and characters and reader. Bakhtin insists: "This interaction does not assist the viewer to objectify the entire event in accordance with the ordinary monological pattern...and as a consequence makes him a participant." (p. 14) The dialogical word is doubly directed — directed toward an object but also to the word and speech of an other. For instance, in the Socratic dialogue, there are two basic devices: syncrisis and anacrisis. "Syncrisis was understood as the juxtaposition of various points of view toward a given object...Anacrisis consisted of the means of eliciting and provoking the words of one's interlocutor, forcing him to express his opinion, and express it fully...Anacrisis is the provocation of the word by the word (and not by means of the plot situation). Syncrisis and anacrisis dialogize thought, they bring it outside, turn it into *speech* in a dialog, and turn it over to the dialogical intercourse between people." (pp. 90-91) For an analysis of the dialogical and performative, see Monk, Philip, "Stanley Brouwn and the Zero Machine," *Parachute*, number 18 (Spring 1980), pp. 18-20.

10. For the rechanneling of exchanges by the receiver, especially through laughter, see Douglas, Mary, "Do dogs laugh? A cross-

cultural approach to body symbolism," in Ted Polhemus, ed. *Social Aspects of the Human Body*, (Harmondsworth: Penguin, 1978), pp. 295-301.

We can think of the excess of Bataille as both an issue and exit from the work of art — the "example" of Bataille's laughter. See Monk, Philip, "Exits," *Impulse*, 8:3 (Summer 1980), pp. 29-31. Also see Bakhtin on laughter and the carnivalesque, and the tradition of the Menippean satire and Socratic dialogue. "Parody is the creation of a *double which discrowns its counterpart.*" *Problems of Dostoevsky's Poetics*, p. 105.

11. The potential of performance does not lead necessarily to potential solutions. Nor does dissolution of imaginary relationships imply a position free from ideology. The subject still finds its image in the social. The question of ideology is: social desire or socialized desire? Finally, performance acts upon the individual, not the masses.

12. Excess is both a going beyond and a going out: excess and exit. *Cf.* Derrida: "This is indeed how things appear: the theatrical representation [in Artaud] is finite, and leaves behind it, behind its actual presence, no trace, no object to carry off...Its act must be forgotten, actively forgotten." *The Theater of Cruelty*, p. 247. While Derrida finds it necessary to exclude the audience, he also finds it necessary to include it so that it can be consumed in performance. There is no position for the audience or the individual after the performance — there is nothing to carry away.

13. To anticipate the assertion that dialogue calls for a fully present consciousness, a consciousness in identity with itself, Bakhtin maintains that "Man is never coincident with himself. The equation A = A is inapplicable to him." (p. 48) Nonidentity is crisis: "...that unique *indeterminacy* and *indefiniteness* which constitutes the chief

object of representation in Dostoevsky: he always depicts *man on the brink* of a final decision, in a moment of crisis, at an *unpredeterminable* turning point in the life of the soul." (p. 50)

14. This avoids Derrida's criticism of the "presence of meaning to the absolute singular uniqueness of a speech act." "Signature Event Context," p. 191.

This essay was first published as
the introduction to the exhibition
catalogue *Language and Representation* (Toronto: A Space), 1982.

# Language and Representation

The projects by the Toronto artists documented here were made for or took form in relation to the exhibition *Language and Representation*. As the title came before, the works seemed called to demonstrate its conjecture; but the works produced did not have to illustrate the "theme" of the title. Throughout the course of the exhibition, the works surfaced within their own conventions and contexts. In turn, this essay does not presume to represent the work gathered under its name. Rather, it considers the problems that this art raises for theory, problems that theory must recognize as its own exclusions.

The artists here do not compose a Toronto school, but in some shared way they work with language and representation outside the formal models presented to them by the art of the last twenty years. It is the representational character of this work, whether language or image alone, or image subtended by language, that is the question here — representation is not *under* question. This "representational" art could be said to form the third moment of language in art (of the language base or conditioning of art) following the conceptual art of the sixties and

the semiotic work of the seventies. It could be said to continue this development if it did not have to present itself as an exclusion from these previous moments; that is, if its representational concerns were not suppressed and forcibly excluded from these previous practices by the violence of criticism.

Because of these theoretical constraints, it is perhaps up to criticism to show that this return is not a reactionary restoration, an *Eighteenth Brumaire* of representation. For if past work has shown that the excluded viewer had to come to speech, more recent art shows us that the referent must come into view. And since the work stands between this viewer and the referent, and mediates them, its reference cannot be the issue of a generalized representation. Its position is one of proximity, which lends the work a local political dimension, and suggests the dedication of this project to the place from which we speak.

## Representation Past

At different times in history, terms are given different values, positive and negative in turn. For instance, in its rise and struggle against a feudal order, the bourgeoisie was progressive, which gave the term "bourgeois" a positive value. In power and against the rise of the proletariat, "bourgeois" was negative. Now even "positive" and "negative" have become invested terms in an overturning of their immediate meanings. Anything positive is automati-

cally ideological, while the negative is critical, as when we say "negative critique."

"Representation" is a term whose stock rises and falls in company with the term "bourgeois." Representation is seen as the ideological means by which the nineteenth century bourgeois declared its social constructions a natural order and thus legitimized its class rule which continues today. Art's own formal reductions, as part of a general critique of representation, were seen as allied to the struggle against the bourgeois appropriation of presence in the conventional, and the material in the ideological. Today, only work that registers representation in a critical way, that presents it in the form of a critique, is allowed. Even the name "work" displays itself opposed to the mere immateriality and non-productivity of representation. To make use of representation without these scare quotes is suspect. To speak positively of representation rather than through the negative critique has become a *theoretical* impossibility. Representation then is excluded, not only in modernist art, but in critical and semiotic theory also, even though it may be a term of their analysis. While we might think that the language and phototext art of recent years may be receptive to representational concerns, conceptual and semiotic art, while seemingly opposed to modernism, are bound by formal models of language. Their aura of orthodoxy has reduced representation in language and image to a negative, that is, ideological, term.

The history of modernism is a history of the progressive

loss of content. Modernism's critique of representation in favour of the immediate, concrete and irreducible established the limits of representability by using the methods of a discipline to criticize itself: what was unique and proper to a medium asserted itself in all its positivity. Modernism sustained itself in this self-criticism, and its history became a repetition of the form of a critique; but it reproduced itself as this *form*, never as what was representable within its own limits. Even phenomenology, in its concern for the contents of experience, repeated the empty form of a presumed presence; as much as phenomenology was a "return to the things themselves," it put the world out of play. Similarly, semiotics, as a continuation of the modernist project, has had to exclude the referent as a disturbance to the purity of the theoretical model. In all cases, reference, representation and the real have been condemned in favour of a material formalism.

While the exercise was to conceive what was representable as more than a remainder, in the end, representation as a whole was excluded from this modernist history. The two moments of modernism — the formal-reductive and the semiotic-textual — have always rejected representation as synonymous with idealism and have championed what seemed impossible for representation: namely, production and the materiality of the sign. But now even these terms must be called into question in their systems of value and legitimation; they must be re-examined *at their word*. (In what sense exactly can we talk of the materiality of the sign, of revolutionary production or transformation in lan-

guage, of the production of an effect by a text or a work of art?) A revalued convention of representation, as an affirmative rather than negative value, however, may take us beyond the reductive exclusions of formalism and the critique-bound orthodoxies of ideological analysis. Rethinking representation even so far as a theory of action may show how, contrary to the beliefs of a materialist aesthetic, representation leads to the social.

## Representation Present

The sweep of condemnation by reference to a name makes representation's use uneasy. Any discussion of representation is bound to confuse it with the representation of traditional *mimesis* and with the historical movement called Realism. Today it is automatically associated with the iconic referentiality of New Image painting. But the works in this exhibition have little to do with the conventions of *mimesis* and iconicity, which in the case of painting (since here it seems for commentators that it is always and only a question of painting) reintroduce notions of style and originality. This is not to maintain that convention and referentiality do not pose two fundamental issues for representation.

In *Language and Representation*, on one hand, we think of representation as *language*, as what is representable by language, and of language as the most flexible system of representation, the only one that can talk about itself. In

representation we do not simply have a collection of factual or descriptive statements with attributable truth values; nor do these sentences necessarily compose a fiction. They are a type of naming that is brought into relation, in cases, with an image or images.

On the other hand, representation is a placing of an *image*, or images, established by various relations between different codes of representation, technological and iconic, that may be schematic or symbolic as well as analogic. Reference does not entail iconic resemblance; it refers somebody to something, but in various ways. The image is hardly ever a single, unarticulated, "natural" image. This dissociation of codes does not oppose representation: the work can be and is syntactically and semantically differentiated.

Sometimes this image is inflected in turn by a text or voice, and complicated in instances by a referent — a visual or verbal naming which sets up another sense of representation. The necessity of reference or naming gives the content a concrete dimension; it is not just the case of a formal coherency of representational codes, or of a reference to a cultural code already in place. This representation by means of a reference/referent may come into play in the construction of a narrative or image by the specific use of material of a (auto)biographical, historical or political nature, or by the ensuing structural positions that the work creates in relation to the referent, one for the artist, another for the viewer.

Reference also distinguishes the representational in this

case from the fictional. Representation does not have to take its traditional form of an organic whole whose composition is transparent to the "reality" it presents. Now its "realism" can still be critical, requiring the cognitive and referential, not just the imitation of an action. But it is not the realism of the "art of the real"; it is not the reality of material, process and context where the referent is structurally effaced. Initially, however, this representational art concerns itself with the structural conditions and problems of representability without forgetting the referent. Representation's return signals more than a regression to old uncritical forms, and yet the problems it introduces are only secondarily formal.

Very simply, I can say that representation is something which stands to somebody for something. That is, a representation stands for and refers to. But having said that, while structural conditions of representability ensue when something stands for another, the relation of representation to its "object" (the something) and "user" (the somebody) introduces the semantic and pragmatic dimensions respectively of the work. These relations take it outside a formal, self-referring system. A work is referential and representative as well as representational.

A representational work is doubly directed: the reference towards its referent (the social real) and the representation towards its audience. The referent is the "origin" of the work and pointed to by the work. On one hand, the artist represents (stands for) the referential origin which comes first and serves as subject. On the other, the repre-

sentation of the work returns to the referent, points to it as subject. (The representation may point to its object in a quasi-indexical manner or point out something in its absence. The relation of artist to referent and audience to representation maintain a proximity even in the absence of an object, an absence that makes representation.) The work then mediates and stands between the referent and the audience, between production and reception.

We take advantage of the double sense of representation's "standing for." Art and politics meet in the word "representation"; and every artistic production contains a representation of the viewer on the model of political representation. As well, the artist must position himself or herself in relation to what is represented (its choice as subject, the referent and social real), but not authoritatively as the representative spokesman; and he or she must bring that representation about by the relations of the codes of representation among themselves in the work and to the viewer.

The formal investigation of representation is perhaps now secondary to what is represented, which is not to say that the work is not critical or that this investigation is not part of the artist's practice or prior to it. But the investigation is not primarily a structural concern, which in the end presents an empty formal model. An erased referent resurfaces, and content returns as a semantics of history. It is by now commonplace to read "content" into the form of a work. History is latent in more than the form of a work. Having been structurally effaced, content returns with all its effects in representation.

## Representation Future

A search for value can only take place through represen-
tation. Revaluation of representation, as other than an
ideological constraint, may be that passage from socialized
to social desire. Presumably this will have a force, or the
value of a force, brought about by representations. Under
the conditions of our history, however, the modernist
critique of value has led to the destruction of all values
without being able to institute any new value except that
which is a formal law, or that which floats. Value is short-
circuited by the incessant repetition of this critique, by the
constant consumption and evacuation of meaning by criti-
cal theory and an art that forms itself on this writing.

   To take a position and to say something is the double
sense of representation's "standing for." To call for some-
thing to take a place, for someone to represent positions
and values, to call a halt to the infinite production of capi-
talist flows, is to call for work at its word. To be more
than symptoms or parasites, clever inhabitants, bachelor
machines or bricoleurs; to be more than Baby Boom Bau-
delaires or critical terrorists; to recognize the crisis of over-
production equally in art and in the market, and not to
accede to a reactionary or recessionary criticism; in short,
to reconstitute the avant-garde in its original social terms,
means to find new strategies or recognize art's limits. Once
we recognize that the seventies art strategy of "inhabita-
tion" of popular media, a so-called disguised or didactic
entertainment art, has no effect outside art's marginal site,

we can accept that marginalization, close the system and find our collective representations, in other words, extrude the utopian dimensions of the art community. At the same time this would be a refusal of this peripheral site through a projection of values and a refusal of the theorization of the margin. But if that does not satisfy us, as condemned as that community is to the same forces of capitalism, neither will the other dominant practice of the seventies, semiotic critique, allow us our say, tied as it is to the "always already there," that is, reflected in the system it criticizes. It permits us a structural position, but no speech as subjects. What is left is both a strategy and a limit, namely representation.

At one time, work at its word would have been the promise of art. Representation loses none of its potentially utopian character in being critical at the same time, as all the works in this exhibition are in some sense. But representation is not primarily critical — based on the model of the critique — because something else is said. The point is to speak *for*, as well as against. To position that other as more than determined, to bring it to speech, is the role of representation.

# Semiotics of Reception

## III

This essay first appeared as "Colony, Commodity, Copyright: Reference and Self-Reference in Canadian Art" in *Vanguard* magazine, Vol. 12, no. 5/6 (June 1983), pp. 14-17.

# Colony, Commodity and Copyright

*Reference and Self-Reference in Canadian Art*

The history of art in Canada is short. That is to say, there is no history. Or there are many. This is one of them. I would like to think that this is more than one history of Canadian art; that this essay could trace a significant development in Canadian art. But given the geniality that has passed for criticism in this country, anything that is produced and written about is put into a history — a history of autonomous objects, of individualistic expression, etc. It is put into a history, not given a history. If it were given a history then we might learn of its conditions of production as well as the conditions of its reception of influences. The latter is a context of misunderstanding as well as understanding. Understood, this art is more likely to make its own authentic history, not repeat one from elsewhere, consume it as a system of signs. This reception, moreover, is a response or a failure of response to its own context and history. Failure to respond is also a condition of its context.

The history I want to discuss, which may be *the* history of Canadian art, is a history of objects and subjects, where the objects have been replaced by subjects. Basically, it is a sculptural tradition, but sculpture that has been medi-

ated by language, so that it might include installation, photo-textual work, video or "pure" language works. What could be taken as a formal development in this work indicates another history. And it is that which is most resistant to history and language: the presence of the work of art. Here I mean presence as the authenticity of art and hence its authority. What is presented to us in the work of art is an immediacy we experience in the work of our presence through its. What is presented to us is separate from the artist but "copyrighted," so to speak, under his name and image (under his authority), both of which are signatures. This presence can be actually registered moreover as an *index* of the artist. In the "examples" through which I trace this history, the artist is "there" in the work as an index: as a photographic index; indicated through the indexical process of the work; or as indicated by the enunciation of an "I." (An index need not resemble its object, but must be modified by it. It therefore has a physical or contingent relation to what it refers to or signifies — such as a footprint in the sand or a photograph. Demonstratives such as "this" or "that" are indices, as are the personal pronouns "I" and "you.")

This presence is problematic; I do not accept its positive description above. It is problematic not only because it has been put into doubt as one of the founding metaphors of Western metaphysics. It is problematic simply for being there. What absence does this presence indicate? Why has the artist or the index of the artist become the subject of this art, emblematic of a formalization of the processes of

art? What does it displace? What reference does this self-reference replace? Why has the index of the artist become the object of the spectator's view? And why can we trace this through much of the most significant Canadian art?

This evidence is more than a theme within the history of one direction of Canadian art. More than a local version of a general indexical strategy, we could call it a theme if it did not express instead an absence of reality. The formal construction of this index as a presence or, as we shall see, a reference is a conscious or unconscious response to that absence of reality. In making the index the formal identity of the work, a self identity is asserted against that absence. If that absence defines our condition as Canadian, it helps explain why a history of art has been impossible. That is why above I called this work *the* history of Canadian art. This third history, now as an absence, has been recognized by this art somehow in its production, but not by criticism.

The conditions of existence of contemporary Canadian art are complex. Not the least is the fact of having passed from pre-modernism to so-called post-modernism without a history of modernism. The work I discuss is situated in that conjuncture between the two. Our lack of a national art history perhaps is implicated in this absence of modernism as a failure of an industrial capitalist class to arise. Our continuing colonial dependency in the transition from mercantilism to corporate branch plant management is registered in some way on every level of culture as a lack of validity given to local production. This repeats in both

institutions and individuals, and the relation of individual to institution, the structure of margin to centre of a hinterland to imperial metropole. (In itself, this "I" is male and central Canadian.)

This work takes its place against the accumulation of absences that make our history. It attempts to suspend this history through an ontology; and it can escape its colonial nature by its acts: how and where it places itself; its recognition of the historical moment and its influences; the considered formality of its construction. In turn, however, each of these is a reaction to and product of a more consuming history than our colonialism, and that is the history of commodity relations based on the structure of the commodity.

"What is characteristic of the capitalist age," writes Marx, "is that in the eyes of the labourer himself labour-power assumes the form of a commodity belonging to him. On the other hand it is only at this moment the commodity form of the products of labour becomes general." We presume the artist privileged to escape the commodity relationship in his work which maintains its organic process and immediacy in the unity of the product. But that privilege and unity is achieved at a price: it is predicated on turning the individual into a subject. It is not necessarily that the artist's labour is a commodity that belongs to him, but that he becomes a *legal* subject. Copyright is the sign of this surrender. The index is its alibi. Copyright supports, the index confirms identity and presence. The absolute relation of immediacy of presence is secured by the

index of the artist — the contingent evidence of his presence. This signature in turn assures the work's value. The museum is the work's (this presence) absolute validation, its signified. The gallery is its means of circulation — its signifier. The viewer is formally excluded; his or her function is to reassure this presence and authority by a consumption and confirmation.

The history of this art is not mere repetition. We find a general tendency from self-reference to reference. Reference and self-reference are opposed: in absolute terms, a work cannot refer to itself and outside itself at the same time. Any interrogation of the formal conditions of self-referentiality is bound to lead to the problems of referentiality in general (by which I mean, for example, the relation of a word to a thing or an image to an object or event). The nature of an index is such that it can register a presence or indicate a reference, and thus lends itself to both reference and self-reference.

Michael Snow's work has remained consistently self-referential. In many ways his photographic and sculptural work from the late '60s set the terms for the serious younger Canadian art that was to follow. The work after is a surfacing from Snow; it is also a move towards reference. Among the terms was the index. *Authorization* (1969) uses "photography in a very enclosed way so that there is nothing outside the work itself that is used in the photograph" (Snow). This work is a record of its process of making: it is an index of it. The set-up of a camera in front of a mirror ensures that the photograph will record nothing

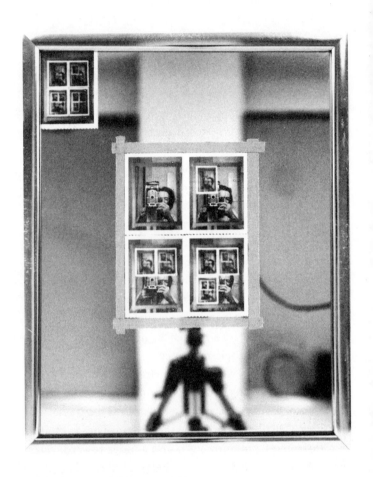

Michael Snow, *Authorization* 1969.
B&W polaroid prints and cloth tape on a mirror
in a metal frame, 54.6 x 44.5 x 1.4cm.
Reproduced by courtesy of
the National Gallery of Canada, Ottawa.

outside the work. The mirror indexes the photographer standing in front of it; the consequent photograph is an index of the reflection; and each photograph is a temporal index of the process of the work's construction. Since Michael Snow is the photographer, his image as well is integral to the piece.

The index of the artist presents itself naturally within the formalism of this piece: he was contingent to its construction. His image also appears "accidentally" in the photographic documentation of *Authorization* and *Scope* (1967). *Scope* absents the object of view in favour of the structure of viewing (it is a construction and frame for looking). The accident of Snow's appearance, however, is the *unconscious* of this work, and all his other presentations. The index of the artist's presence, even when he does not figure in this phenomenological work, is the guarantee of our own. The name of the artist is never separate from this presence: Snow's film *Presents* (1981) is both "Michael Snow presents" and the present moments (presence) of its viewing.

The artist, Michael Snow — his image, his name, his history and that of his work — becomes a formal constituent of his work. He "appears" through means of the photographic index in *Venetian Blind* (1970), *Two Sides to Every Story* (1974) and *Cover to Cover* (1975). Or he is referred to in his absence by his name, as in *So is This* (1982), or its variants, e.g., "Wilma Schoen" in *Rameau's Nephew* (1972-1974). With Michael Snow, we have more of a self-given history, which does not mean self-expres-

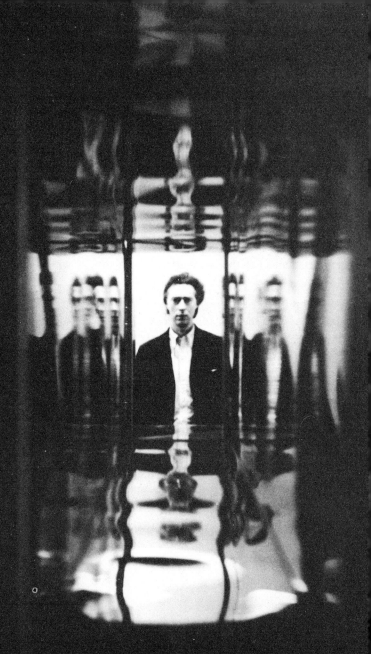

Michael Snow, *Scope* (detail) 1967.
Stainless steel/glass, 175 x 396 x 91cm.
Reproduced by courtesy of the Isaacs Gallery, Toronto.
Collection of the National Gallery of Canada, Ottawa.

sive, than that of any other artist in Canada. As such, his 1970 retrospective catalogue, *Michael Snow/A Survey*, is a rich social history of a *Canadian* artist as much as a document of a body of work, re-presented in the process of a bookwork. Perhaps we can look into that exemplary social document for the reasons why the social referent itself is missing from his work. This is part of our history, and history of art. The social is always returned to the formal when it becomes the index of the artist. What the index of the artist always guarantees is the formal autonomy of the work.

If Michael Snow mined his own proper name and biography as formal material for his art, General Idea appropriated the *fiction* of their own history. Their name already is a copyrightable corporate symbol. Now rather than one artist to be indexed, three terms are put into play as a system. The lens and mirror of Michael Snow have become "mirrors mirroring mirrors" in General Idea: a mechanical mode of production has given way to the semiotic. The former one to one relation of object to index or index to referent — as part of the mechanical process grounded in the phenomenology of perception and the apparatus of the work's construction — has been elevated into a free-floating system of signs of absolute interchangeability and self-referentiality. Any referent is excluded from this system in order that it may function.

We all know the story of General Idea: "This is the story of General Idea and the story of what we wanted. We wanted to be famous, glamourous and rich. That is to

say we wanted to be artists and we knew that if we were famous and glamourous we could say we were artists and we would be." As the last statement indicates, this enunciation strategy is tautologous — a mirror image of itself, the mirage of a constitutive act. On the model of fashion, General Idea have done much to create a scene and a place for art in Toronto. Their work, however, is marked by the consequences of that necessity: it reflects the lack it signifies — the position of art in Canada. The necessity of making a scene, of creating their own institutions of support and distribution have infiltrated their work as a metalevel. This metalevel is the form and content of the work; its enunciation is the simulation of its own effects. General Idea's resort to ambiguity, the multiplicity of meanings, an expanding system of verbal paradoxes, and their own self-referencing system has a tendency to raise the work in its entirety to a metalevel that is ideology itself.

The fetishistic self-referential formality of this closed system has its consequences. In a system where signifiers exchange among themselves outside of any relation to a real or referent, no critique or reference can take place. The model of this system of value is based ultimately on capital. General Idea's strategies of metalanguage, appropriation and artificiality, "borrowed" from Roland Barthes' essay "Myth Today," reproduce the effects of semiology itself: the tendency to distance itself from the real by instituting itself as a formal system of value (which it justifies all the same by reference to its "language-object" to which it stands as a metalanguage). "The 1984 Miss General Idea

Pavillion," as a third-order semiological system, is thus an expensive construction and luxury for us. Like myth, as a system of value, there is no adequation between it and the real; it is referentially self-sufficient, although ideological. It has no referent other than its own construction and past history, composed of a string of signifiers, a pure fabrication that does not need a referent: "We've tried to underline the fact that there is nothing behind it. No verso to speak of. The task of stringing together enough evidence to present the case is a labour of pure fabrication." The referent is lost in favour of the system itself: its own history, and the story of General Idea, becomes the function of this system. As a recent statement on the Pavillion's "room of the unknown function" (itself a statement emblematic of its own formality) puts it: "the three artists of General Idea have reintroduced destruction into the architectural process. In their long-term project, the 1984 Miss General Idea Pavillion, ruins are created as quickly as rooms are built. Accumulated layers of function and meaning slip in and out of focus, creating a shifting constellation of images which is the Pavillion itself." The system can accommodate destruction because it enters the system as its mirror image, as its absolute reversibility which is always already inscribed in the logic of the system.

Robin Collyer's sculptural ensemble *I'm still a Young Man* (1973) was pivotal in the change from formal objecthood to referentiality. The personal pronoun "I" of the title referred to the proper name of the artist; but the title as a whole gave a sense to the work through its references

in the work and their referents. But it is another work that uses an "I" less positively that is relevant here. In *Something Revolutionary* (1978), a text of six phrases accompanies six colour photographs — upside-down shots of a ceiling, the latter three through which a film reel spins. The text reads:

> *I am unimpressed by recent movements*
> *I need a new direction*
> *Something to believe in*
> *To have faith in*
> *An activity to turn to*
> *Something revolutionary.*

We are immediately disoriented by the photographs, an alienation that is furthered by the statements, which seem to talk down to us, and which we have a hard time applying to the photographs. In spite of that disjunction we can cue the phrases to the photographs by applying the literal definitions of "movement," "direction," "turn to" and "revolutionary" to the progressive tilting of the photographs and to the turn of the film reel. In the context of the statements, however, these words have a metaphorical force, and they refer to values. The narrowing of semantic reference by the purely physical "interpretation" or illustration given by the photographs reinforces the impasse between content of expression and action. Action remains suspended, in the air. We cannot stand to this upside-down space nor act on these statements — make

them performative. Even the implied continuity to the sequence, which is reinforced by the sequence of phrases, is denied, not only in the gap between the discontinuous spaces of the photographs in presentation, but, as Philip Fry has pointed out, within the photographs in the implied narrative of the spinning reel. The sequence does not necessarily describe an event; it is a fictional construction more than the indexical process we find in *Authorization*.

If objects have moved towards language mediated by reference in Collyer's work, because they have become language in some cases does not mean that the work parallels and repeats the evolution of the commodity from object to sign system. Reference intervenes, as problematic as it was expressed in action in *Something Revolutionary*, to reduce the general commutability and nihilism of signs, products and people that is our alienation in everyday life.

In 1978, Andy Patton started a series of language posters that were contingent to their sites. The first were descriptive, except the gap between description and site, between language and its referents, was intended to demonstrate the inadequacies of convention in general. The poster and site met in one word only with the repetition of an actual word in view in that location. It was as if that one word carried the whole weight of difference, as language strained at identity, as if the inadequacies of language in that site disputed the direct relation of work to spectator in the gallery. Instead it aimed for the audience of advertising — mass and accidental.

These posters appeared, disrupting the "naturality" of their industrial, urban settings; but they offered no message. They did not address us. An act put them into a site, but an intention or a voice behind this writing was absent. Patton's poster of November 1978, made for the Toronto civic elections and placed over mayoralty posters, directly addressed a viewer through an "I." Yet this "I" was tentative, unhappy with both the inexpressibility *and* objectivity of language. Against a form of political advertising that called for a referendum response on the part of the viewer/voter — a yes or a no to this face and name (the same stimulus-response of product advertising; the same face and name of the indexical art talked about here) — Patton inserted an individual voice. This insertion caused a wavering of advertising intent. It also pointed to questions of legitimacy which ultimately are questions of property. The election posters were legal, Patton's "defacing" illegal. The poster directly confronted this apparatus of legitimacy rather than inhabiting its structure as a pseudo-advertisement. As uncertain as its message was, this direct, self-representational speech forced a halt to the equivalence and interchangeability of advertising and political messages that also speak with an "I" or address the viewer with a "you." Addressed as a "you" singly or collectively, our function is to buy the image; we are alienated from this political process while having a function within it and for it.

The direct speech of Patton's poster, however, is only the simulation of directness. It does not refer outside itself or lead pragmatically to action: that reference and reality

is still problematic for it. It intervenes as an act by interfering with the structure of the political poster. But by situating itself in a place where it cannot act — in that political process; by accepting that "site" of the poster for its intervention; it expresses instead an inability to act (much as that inability expressed in *Something Revolutionary*). No longer is it a question of the inadequacy of language here: language is the only place for this subject to act.

The last posters (1980) retreat from this recognition. They take the attempt to blur the semantic markers of the conventional gallery context or sanction and to provoke a non-intentional response to its logical end with the reinsertion of the site in a site. These works were photographic reproductions of other postered sites; they indexed the nature of the poster, not its actual site; and they were grouped to make the appearance of an intention. The index here is as much a desire for absence as a desire for the utopia of pure process and presence. As I have written elsewhere, "this extreme of self-representational and self-referential act functioned through the delay of insertion and differential interruption. But it reflected a nostalgia for the site, a utopian desire for the surface of the world, for pure productivity in an urban capitalist reality."

All of Tom Sherman's work is the presentation of an "I" and an image. But now this presentation is not positive or problematical: it is the subject of the work. The presence and authority of the individual voice of the artist's "I" — the artist who speaks truthfully or imaginatively as the guarantor of the presence, truth and effectivity of the

work — is undermined by another strategy that moves through the work constructing the work as a fiction and displaying it so. This becomes a model for every other presentation of information that speaks through an image as an "I" but not with an "I" and composes facts in a fictional mode, as, for instance, news broadcasting. Here reality is constructed by the media; it is represented through the alliance of technical reproduction and codes of authenticity that operate through the simulation of reference.

Two works from 1977 and 1978 use the "same" text juxtaposed to two different images of the artist "Tom Sherman." In the first, a publication, a photograph of Tom Sherman with eyes closed, head tilted back is juxtaposed to a printed text. In the second, the videotape *Envisioner*, another image of Tom Sherman flashes between parts of a character-generated text that is excerpted from the soundtrack. The text is the same, "Tom Sherman" is the same, but now the artist looks straight towards us with eyes open. The two images oppose insight and authority; but as the text remains unchanged, the opposition breaks down as a vacillation of the same. We are made aware of the manipulation of the codes of realism in documentary and "confessional" first person texts, texts that operate on the basis of objectivity or sincerity established by reference to certain so-called referents of detail:

To appear authentic in conversation or print I enrich each sentence I pronounce with a bit of general detail; perhaps I quote a number or tell a temperature or exag-

gerate the adversity of conditions affecting my body. For instance it burns my ass to hear people advertising their "1 of a kind" identities.

In analyzing all this work we do not have to accept traditional or critical categories which tend to autonomize the individual work of art. Instead, we can place these works in position against a referent and ask how each treats it. Do they reject, obscure or direct us to it? For each of these cases we have to go beyond the formal construction of the work — what is given and what is given institutional support. We have to go beyond to understand what lack that reference or lack of referent is expressing.

For Michael Snow's self-referentiality, the referent never appears; it is not allowed in the concept. For General Idea, the referent is irremediably lost in a fetishized system of value: the "we" and the multiple images of the artists no longer even serve as indexes. The loss of the referent for them is no crisis as it is for Robin Collyer. He integrates the referent into sculptural work in the gallery in order to dispute the subjection over us outside the gallery of communications systems and representations. Andy Patton's subsequent work, which took over advertising formats, recognized that action, as constricted as it might be, can take place within convention. At least that is where it is directed against us. As for Tom Sherman, that referent must serve within a fictional enunciation for the purpose of communication and not for the dissemination of personality, as the death of the artist. For all, there are

broader social and economic questions to ask about the loss of the referent and the struggle to regain it.

This analysis is not completely historical; it still refers to the present. Only the dynamics of the image have changed. The new painting or new expressionism restores this same subject to art. Its (coded) expressivity is a guarantee of the work's presence and immediacy; its gestures are the signature of the artist. But this painting restores itself and the subject at a more regressive level; objectivizing technique (the mechanical record of index) or the conventions of language have not intervened as in the work discussed above. These conditions alternately alienate the viewer from the work and refer him or her to something else. That is, they work for the viewer. Painting's expressivity, on the other hand, is completely institutionalized. It restores the most traditional image of the artist for the artist's and our consumption.

This essay first appeared as "Staging Language, Presenting Events, Representing History: Ian Carr-Harris" in *Vanguard* magazine, Vol. 12, No. 9 (November 1983), pp. 18-21.

# Staging Language, Presenting Events, Representing History

*Ian Carr-Harris, September, 1973*

Ian Carr-Harris' exhibition in 1973 may pass as historical in the transition of Canadian sculpture from formal self-referentiality to reference outside itself. It certainly has to be recovered historically, to be regained as an event. That recovery is appropriate since history and event were so much the subject and presentation of that work. To recover that event is to treat this article as a review, as if no critical hindsight had been gained since. Through this critical experiment, a formal division disturbs the continuity of themes before and after this cut into a career, and even the proximity of the artist's name to this work. This cut into a continuity gives the work an undue presence while at the same time denying that presence: it too is split.

This reviewing is not an attempt to re-present the works — to let them stand in their particular presence. The works themselves were divided in presentation. An exhibition is a form of presentation; its space is not an empty vehicle. These works took into themselves this format and framing. They stage a presentation. What are these tables but stages for the presentation of information that are events themselves. What the works stage is language. What

Ian Carr-Harris, Installation photograph of a solo exhibition at the
Carmen Lamanna Gallery, Toronto, September 22 - October 11, 1973.
Reproduced by courtesy of the Carmen Lamanna Gallery, Toronto.

they stage are language-events. By their means of presentation they are "here" in the space of the gallery, but within their frames they represent something else. They are bifurcated as a presence and a reference, a here and an elsewhere, a now and a past, a history and an event.

Seeing the exhibition in 1973, the sculptural context and spatial presence might have been more obvious than it is to us now. Through documentation we tend to read the work and see the language as information. Looking now, we might too readily read the image-text conjunction alone and forget its presentation. Thus we might reject the work as a dated conceptualism or a simplistic semiotics. Then, the sculpture was familiar, as exaggerated and elevated the tables might be. Minimalism and Duchamp would give us ready reference and access. Then it might have been what is most conventional, that is language, that defamiliarized the work, alienated it from us. Now it is the reverse: language thoroughly familiarizes us with the work. It completely dominates the image as well as effaces the literality of the sculpture. Semiotics has made language transparent; we forget the quirkiness of its formulations and presentations, as we have forgotten these works.

What do we make of these tables? The relationship between image and text enacted there is not so simple. The tables are theatrical and utilitarian at the same time — staging language and providing a base for its presentation or representation. But as a whole (table and text), the work is a theatricalization of language and situation, and of our situation there. Frames function like tables. There is rea-

son for both being together in this exhibition, the one on the floor, the other on the wall, as well on the tables. Tables and frames separate language from a particular context of use by throwing a spotlight on it or by making it into a snapshot, so to speak. They act to turn language (or image) into a quotation. As a quotation, it is not secondary to an original use or presence. Its cutting does not signal it merely as a representation. It can be observed (as a representation) or taken over and acted upon (made performative by use). By that cutting out, that defines a representation or a quotation, these devices of presentation lend the quotation a density that makes it into an event that has its own space and situation. Moreover, we are part of it: the stubborn case of its presentation and our presence there. Language here has the force of a demonstration which can also serve as an example.

The 1973 exhibition at the Carmen Lamanna Gallery then has the force of a demonstration, but it also acts as the space of a classification. The gallery space itself becomes a table of classification. Six tables and six wall-works date from that year; two others are from 1971 and 1972. Although different in nature of construction and installation, each work partakes of the same type of presentation. Each table and wall-work offers a different formal set-up. All the possible variations of image and text in presentation are given, each in a separate work. Thus the space of the exhibition serves as that formal classification with each work as a logical variant. But beyond that formal differentiation, each is a demonstration of language — a case

of language where image (or reference) initially is second-ary. That illustration, however, has the power to cause a division within language and between that initial identity of language and image.

Whenever language appears here there is no meaning to any particular statement: the semantic content is pro-vided by an illustration or a reference. Language here is to be acted upon by means of that reference. That is, the sentence or phrase is not a logical proposition with attrib-utable truth-value, a linguistic entity, nor a means of com-munication of a message. By being taken up and acted upon, a difference appears, an identity is split such that there is a temporalizing and a spatializing that asserts the work as a whole as sculptural.

This is the function of the overlaying or juxtaposing of text and image, of doubling the frames and the instances of the "examples" they contain, or of splitting a presence with a language reference. We never find a simple or nat-ural relation between language and image. If we do, we have not put the sculpture to work; we have not separated out the relative weights, relations and registers within each sentence itself and in relation to an image. We have not made these works into sculptures.

*"QUICK! he said, grabbing me."* This statement appears without quotation marks in a frame standing on a table and overlays a photograph that seems to illustrate that "event": a man awkwardly grabs a woman's arm. That awkwardness arises as much from the man and woman standing with their backs to us (to the camera, rather), the

man grasping the woman's left arm with his left hand, as from the fact that they seem staged to illustrate the statement, rather than the statement referring back to or narrating an actual event. Already there is a vacillation between documenting and narrating. Which — text or photograph, event or representation — is secondary? Which illustrates the other? By being separated from the continuity of a narrative or an event by the quoting procedures of table and frame, language and photograph, this is an event in itself. But it is an event marked by discontinuities.

Within the continuity of this narrative and the grammatical unity of the sentence, we find different forces, registers and functions that serve to dissolve a sure and natural illustrative connection between image and text. Divided into the three parts of its syntax, we have a quotation that is reported speech, a narration and a representation of action respectively. Just as we find divisions within this sentence and between it and the image, so we are split in front of the work. There is no simple position for us corresponding to the subject-predicate, subject-object structure of a proposition. We stand in front of the table, held at a distance by that ribbon of text that passes over the image and intercedes between us and it. It is not a script that refers or points us to the subject matter as in a medieval painting. We stand in front of that particular table, separated from the other works on display, cut out from that space by the framing and quoting devices, and we find ourselves divided in front of the presence of this work that is divided itself. The event is uncertain; it is delayed, split in itself.

We duplicate that split in registering the forces and divisions within the work. Each time a viewer takes up that "he" or "me," a deferred presence duplicates that awkward standing in front of the work, facing those backs as in the Magritte painting of a man facing a mirror and seeing the reflection of his back.

This division between language and image, between work and event, is repeated on the walls. On the floor, tables and frames are nested, like Chinese boxes. On the wall, divisions occur by doubling: there are two frames. Although similar, they repeat something that has to be discerned as different. They do not simply illustrate or demonstrate: their differences must be forced apart. Take the piece whose two texts, one per frame, read: *"A man illustrating the muscles of his back; Lynn, demonstrating that her work is never done."*

At first sight there seems an identity between image and text in these two frames. In the first, a photograph of a page ripped from a book, a man illustrates the muscles of his back. This description here "proves" the identity of the two. In the other, a black and white photograph with flesh tones touched in, a nude woman, "Lynn," stands against a wall, demonstrates that her work is never done. The sentence constructions are nearly the same: parts could be substituted, subject for subject, verb for verb, predicate for predicate: man/Lynn; illustrating/demonstrating; the muscles of his back/that her work is never done. Yet, there is a difference between "a man" and "Lynn," between "illustrating" and "demonstrating," between "the muscles of his

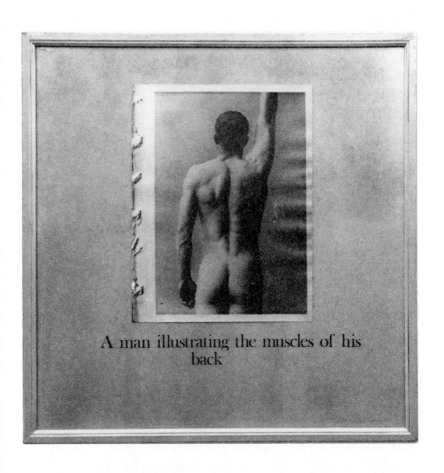

Ian Carr-Harris, *A Man Illustrating* 1973.
Letraset and photograph on painted masonite, framed,
two units, 58.8 x 58.8cm.
Reproduced by courtesy of the Carmen Lamanna Gallery, Toronto.

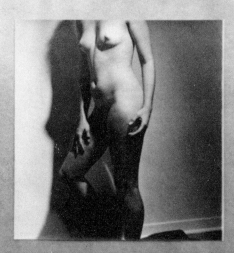

Lynn, demonstrating that her work
is never done

back" and "that her work is never done" even though they can be substituted for each other in the sentences. It was evident when the phrase "that her work is never done" did not describe its image in the way that "the muscles of his back" did. With the phrase "a man illustrating the muscles of his back" there is an adequacy between image and text — a pure illustrative relationship. The body is constructed, serves as a representation, for that purpose of illustration. It is an object; the man is a general type — he occupies the space of a pure example. But "Lynn" is a proper name; "demonstrating" has the force of an action rather than a representation; and "that her work is never done" is not a predication, but a social relation in the world indicating a social construction of the body. The stereotype of that phrase is dissolved in an actual social relation, shown under the name, not type, "Lynn." No longer illustrative, it passes between an action and a relation of power. Its action is disguised and divided. Here on the wall, sculpture is displaced: to the social real. This work stands to sculpture as a metalanguage, illustrating the relations between bodies, classification and power.

Thus the difference between illustrating and demonstrating initiates a whole series of works illustrating *and* demonstrating types, classifications that are social relations at the same time. In *Wendy Sage, being compared with Elizabeth Taylor* two individuals, two names, are compared. To what end is this comparison? Both are individuals; both are named by their proper names; but both are marked differently by these proper names and one is measured by the

other. One is an individual shown in all her particularity. Even though we do not know her or know if the label is lying, her name, "Wendy Sage," is stubbornly attached to her. The other is a name of a star, a name that passes into circulation detached from that body. That name belongs to the construction of a type, an apotheosis of singularity which is a stereotype and a measure — the movie star. Our relation to that name is to a connotative series, not to its denoted individuality.

While in Western culture that proper name ensures our proper individuality, in anthropological documentation one individual can stand as representative of a type. We find this quoted in *Mussurongo Types/Girl at Huila*, two pages photographed from an anthropology journal. There, on one hand, two men stand for Mussurongo types, and, on the other, one girl, photographed front and back, represents Huila. What we would take as a record of a particular event or individual — the photograph as snapshot — serves to classify a type. The apparatus of the lens is one more grid of classification, of mastery. Classification is power as much as it is a form of knowledge.

Just as anthropology determines the limits of Western culture by distinguishing inside and outside (rational and primitive), so designations of high and low within a culture become marks of power as well as grids of specification. Those who have power, have the power to classify and the power to specify, that is, the power of reality. One work juxtaposes high and low, marking this event as a difference of forces more than an accepted opposition. Like

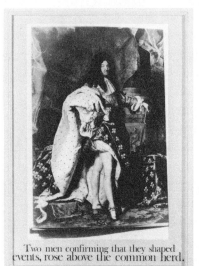

Two men confirming that they shaped
events, rose above the common herd.

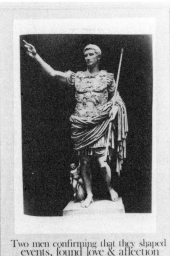

Two men confirming that they shaped
events, found love & affection

Ian Carr-Harris, *Two men confirming...* 1973.
Letraset and photograph on painted masonite, framed,
two units. 58.8 x 58.8cm.
Reproduced by courtesy of the Art Gallery of Ontario, Toronto.

*Wendy Sage, being compared with Elizabeth Taylor, I am the Queen of England...* sets official construction in an elaborate painting of Elizabeth I to the popular expression of a ditty; "I am the Queen of England/I like to sing and dance/And if you don't like what I do/I'll punch you in the pants." The rhyme begins to repeat itself, and this repetition enables its multiple use, whereas the singularity of the painting ensures its individual ownership.

The low and the outside — workers, primitives, children and women — are generalized into types. The inner elite are unique types — movie stars, heads of state, Kings and Queens. These are and are not specific individuals (after all the King of France as a name was occupied by different individuals over time) as much as unique types. They are those who have the power to impose this distinction upon themselves. The two extremes of typification can be compared across the exhibition in *Mussurongo Types...* and *Two men confirming...* If the photograph has given a power to depict, in the past being the subject of a painting or a sculpture meant the power to be depicted. Here then are two historical figures, Augustus and Louis XIV, in two representations of themselves (likenesses) that are representations of their power at the same time. As they are taken from photographs in art history books for this work, they stand as examples of art — Roman Imperial, French Baroque; but through the power of their regimes their names as well have passed into styles. Moreover, according to the great man theory of history, they are the names behind historical events. Thus the texts, one to each:

Ian Carr-Harris, *A Section of...* (detail) 1973.
Stained wood table, hair, plaster, and framed text,
overall dimensions, 122 x 72 x 53cm.
Reproduced by courtesy of the Carmen Lamanna Gallery, Toronto
Collection of the National Gallery of Canada, Ottawa.

*Two men confirming that they shaped events, rose above the common herd.*
*Two men confirming that they shaped events, found love and affection.*

According to the force of their desires they shaped history, "rose above the common herd," and by the same measure of their acts "found love and affection." What confirms? Their poses, this record of their power, confirm that they shaped events and shaped this image. We do not find testament from the other side. Only the identity of the first part of the statements suggests the possibility of the truth of identity of "rose above the common herd" and "found love and affection."

These men are not named in this work except through a general description that we take to apply to them by contingency. In others, names of historical personages, and not images, serve to construct the work and to decompose its assured presence as a sculptural object at the same time. On one table, a plaster cast of a man's thigh is set against a frame that contains the statement: "A section of Julius Caesar's left thigh as it appeared when he mounted his horse to cross the Rubicon." We are referred to an historical figure (Julius Caesar) and an historical event (his crossing of the Rubicon). Within that historical event we are directed to a dramatic moment (the mounting of his horse before...) and given the evidence of the plaster cast (a section of Julius Caesar's left thigh as it appeared when he mounted his horse to cross the Rubicon).

All the following are references: recorded events (biographical, historical); dates; proper names; and they appear in the statement in the work. But, of course, this physical evidence, the section of a thigh, is an impossible reference. Since it is a cast whose imprint is unique and contingent to what imprinted it, it is an index which is a type of reference. But it is not a reference according to the statement whose proper referent would be Julius Caesar. While the language reference refers us to another time and place, or to another book, this thigh *dis*locates this piece. As an index, it is here; as a reference, it is connected to an elsewhere. A mere name disturbs. But this thigh is no conceptual disturbance; it is actually there in front of us.

By cutting into the continuity of Ian Carr-Harris' work, this dislocation has turned against me. Initially I thought to take this exhibition as an episode and example of my thesis on reference in Canadian art. With all its logical problems and theoretical shortcomings, I thought of reference as the possibility of a vehicle, a relay or tie to the real. A reference refers outside itself; that is its potential. This sculpture from the early seventies seemed on that way. But we find here instead that reference (by name or description, language or photograph) is only one form of classification, a classification of types more than particular things, not a tie to those things themselves. How could I think to attach the sculptural object to a particular thing or event by means of a reference? Unless it was statuary, which it is not. Nonetheless, the original security of sculpture or statuary is not certain here. Language and photog-

raphy infiltrate this sculpture's objecthood, so that its presence (and singular statuary reference) is no longer simple. Not only has it been split by language, it has been complicated by reference. Reference directs us from one place to another. An original place and presence is deferred by this division of place. Though we are in that place, we too register that division. Even in its failure, then, reference contributes to the critique of presence, a presence maintained by modernist and phenomenological formalisms. The failure of the referential value of the proper name falls back upon this sculpture and denies its self-presence and self-proximity and any proper analogue of our presence to its.

This sculpture is an object that is a presentation, representation and reference all at the same time, or rather at deferred moments. Language and photography are those means of reference that seem to undermine the self-contained, existential presence of the sculpture — by the fact that they are other than sculpture, and by the fact that they are referential, that is, point away from it. Another figure intervenes in this situation, to make it a situation: the body of the viewer, which bound to the work is of the order of an event, with its own history and contingency.

We are tied to that situation for a duration, as with minimalist sculpture. Our presence there, however, is not as secure as minimalist temporalization made it out to be. As we stand as an "I" to this work, so we should note that the personal pronoun, called an indexical or shifter, is both conventional and existential; it has a proper use each time

that it is used in speech. The particularity and contingency that we attach to our situation there could be lent to giving the work's reference, or reference in general, a reality. By the evidence of this work we have not found that reference to be secure: it is split. Initially pointing away, it returns to the sculpture and returns us to our space in front of it. This is both an event and a structure of identity; but an identity is split in this temporal movement. Both presence and reference are divided; presence is delayed as much as references are cut off and events deferred. Splitting that space may undermine that sculpture's presence as well as our own. But splitting produces a spatializing and temporalizing that could only be considered as sculptural. Remaining sculpture under these terms undermines sculpture's original presence and identity, as well as our own and the artist's. We should remember, however, that we too are a disturbance to that sculpture's presence. We are the possibility of a relay to its references. As reference points out and returns to the sculpture, it points to us: we may be its referent.

There are no titles to these works. They are referred to simply by abbreviating the text to the first few words. Neither does the artist stand to these works. He is detached from them if we accept the logical consequences of this use of reference. Neither the work nor the exhibition can be secured under the name of the artist. This name abbreviates to an "I" in another language, "ICH"; but it too is split in its doubling: "Carr-Harris." Announced by this name, the exhibition cannot take place under it. As much

as the exhibition is referenced to a space ("Carmen Lamanna Gallery, Toronto") and a time ("September 22-October 11, 1973"), it cannot be classified and take a place. Paradoxically, it cannot take place.

This essay was first presented as a
lecture entitled "Sentences on Art"
in the YYZ series "A Critical
Structure(ing)," November 22,
1982 in Toronto, and published as
"Editorials: General Idea and the
Myth of Inhabitation" in *Parachute*
magazine, No. 33 (Winter 1983),
pp. 12-23.

# Editorials

## General Idea and the Myth of Inhabitation

Whenever a person reveals something, one can ask: what is it supposed to conceal? From what is it supposed to divert the eyes? What prejudice is it supposed to arouse? And additionally: how far does the subtlety of this dissimulation go? And in what way has it failed?

<div align="right">Nietzsche</div>

1. Who is the sentence of use to?
2. Who does it claim to be of use to?
3. What does it call for?
4. What practical action corresponds to it?
5. What sort of sentences result from it? What sort of sentences support it?
6. In what situation is it spoken? By whom?

<div align="right">Brecht[1]</div>

## Sentences on Art: Editorials, Intentions and Strategies

An editorial is on the edge of a work. Peripheral to the work's intent, it perhaps is an intention itself. Such is the intention here: to look at a selection of editorials from

*FILE* "megazine," a Toronto publication, edited and produced by General Idea as a networking tool and a vehicle for their own work.

Like a caption or title, the editorial first of all is a matter of language. As such it seems that it is outside the limits of art. As an outside of art, language poses those limits. But somehow it seems to infiltrate back into that object or image. Language begins to effect what that object or image is, determining it or at least directing us to its coherence within a meaning system, i.e., a language system. That is, it editorializes. Language then determines the effects of art, or rather its seeming effects, in effecting the discourse of art. Object and viewer are two nodes in that system. Between art and public, the editorial is a limit-effect, what we expect of a limit-work, but it is also intentional. As the site of these effects, the editorial is also the site of the politics of art. In order to see whether art can be political, in order to discover what it really is serving, we have to understand the limits and effects of art. Whether art "acts" "inside" or "outside," the limit is the effect. And in order to understand the effects of art, we have to examine the language of art and its strategies. Thus, the editorial. For General Idea, however, the editorial is neither representative nor a stance. Its traditional role is subverted in their strategy. Or is it? If not, the editorials can be used to interrogate General Idea's work.

Is the editorial fully intentional or not for General Idea? In the Summer 1978 issue of *FILE*, "1984, A Year in Pictures," the editorial stated "the impossibility of writ-

ing editorials." But General Idea had one intention: "We wanted to point out the function of ambiguity in our work, the way in which ambiguity 'flips the meaning in and out of focus' thus preventing the successful decipher-ing of the text (both visual and written) except on multi-ple levels." Thus they want to point out a strategy of plurality. Yet this plurality is constructed. In the same issue, under "Three Heads are Better," this statement appears:

Once we arrive at certain decisions, we go over our lines. Every decision is like a new word added to an expanding vocabulary. When we're certain we're all fluent we are ready to construct our structures. Con-stant rehearsal make the words second nature — let's call it culture.

Language institutes *value* in the art system. At any one moment it composes the "totality" of the system of art, its creation of value and meaning. It constructs the sub-ject of art, both the subject as what art can "say" and the subject as viewer. It is a system of interest, a system for the creation of value in its "disinterest," a will to power of dis-course whose "truth value," established by the system and not by its commensurability to any reality, is verified by the function of the viewer.[2] Perhaps it is not so much a system to which art itself, galleries, museums, criticism and art history and the popular press all contribute, as an insti-tution; not so much a system of utterances, which leads to the notion of transformation within a formal system,

as a specialized rhetoric of the avant-garde.

In Toronto, or Canada, this system of discourse is incomplete, although not undervalued. Its chain of mutually supporting elements and apparatus is broken locally. So the discourse is dependent on our distance from a centre and our mode of reception of that centre's dominant discourse through the art media, already a mediation of language. This discourse can be acted upon, however, to whatever degree it is understood or misunderstood in reception and application. Strategies then are part of this language system. Oriented to the discourse of the broader system that is disseminated to Toronto, through the transmission partly of General Idea and *FILE* magazine, these strategies have more to do with the manipulation of a sign system than with the material production of art objects themselves. Visual signs align themselves as a secondary system to the primary strategies, the always already there that comes from elsewhere. They are constructed to prove the strategy as much as to illustrate it, that is, to effect it. They are never apart from a language enunciation or referred back to it as one element in the construction of the system. Once again the editorial.

In its narrower intentional sense, a strategy develops from a concept given value under a name. Properly speaking, it is not exactly a concept. Moreover, this discourse or strategy is not contained in any one work; nor is it necessarily registered as an individual intention. A strategy has something to do at first with a force of attraction and then enters as a differential force into a system (becoming

value and investment). It enters, as its name implies, as a strategy. It is necessary then for criticism to examine whatever is represented by this concept, its role, logical position, its genealogy and consequences. It is necessary for criticism to take nothing at its word, and everything at its word. We can start with the contemporary master strategies "appropriation" and "inhabitation."

"Inhabitation" and "appropriation" are similar but not identical in strategy. In a way, inhabitation is merely the postmodernist inflection of the modernist strategy of appropriation, as if postmodernism was nothing but the passage of modernism through French Textual theory.[3] General Idea's strategy is based more closely on the model of inhabitation and it is enunciated as such. It is enunciated precisely because it is a formal language strategy, as is appropriation.

In approaching the strategy and enunciation, we collapse that strategy into the enunciation. We shall find that the enunciation formally effects the strategy, and not that the work has an effect recorded or theorized by that enunciation. Here the two quotations from Nietzsche and Brecht that head this article come together: on the one hand dissimulation and on the other language at its word. A statement may dissimulate its intentions and be mistaken about its effects while it tells the truth about itself at the same time. The dissimulation is not on the order of what is said, but in the strategy. In spite of the intention of the artist, we take the work at its word, accept what the enunciation is actually saying with none of the irony its fictional

and formal construction demands. By doing so we will realize its actual formal, rather than intentional, effect. That is, rather than presume that the statement fulfils a function within the structure of an intention we immediately disregard the strategy and directly accept at face value what the statement is saying. Even General Idea in "The Miss General Idea Vehicle" tell us "you'll just have to take our word for it for now."

This is the same and yet opposite procedure from what Roland Barthes proposed in "Myth Today": "We now know that myth is a type of speech defined by its intention...much more than by its literal sense...; and that in spite of this, its intention is somehow frozen, purified, *made absent* by this literal sense...."[4] Here I propose it is the opposite: that the literal defines the myth and not the intention; that the literal makes absent its literality by directing us back to the intention — to what they say behind the enunciation, that is to the intention of the strategy: the critical effect of inhabitation. And yet perhaps the literal tells the truth about itself and the truth of its form. For instance, in General Idea, if a work "inhabits" capitalism as a "positive" model of appropriation, we can put the strategy in suspension (i.e., the supposed critique) and view this statement positively. Thereby we question whether the critical device itself is not in turn a tool of capitalism, that its form is not the same. Perhaps the supposed content is only a disguise (a fetish) for form and its reproduction. Is this strategy of inhabitation then a critique of capitalism, or a ruse of capitalism?

More than three individuals, who after all are protected by a name, it is a strategy that I am questioning the value today. I could trace the influences on General Idea through the history of their work. But as I am talking of strategies, influence is a notion that only diverts us from examining the *form* of the strategy itself. It is on the level of form rather than content that this strategy in the end rests. What follows then is not a game of parodies, plagiarism or tracking influences.

## General Idea: Where Fascism and Anarchy Join Forces to Create a Work of Art?

I do not want to belittle either the history or enterprise of General Idea. They have done much to create a scene and a place for art in Toronto. Their effort in doing so however is marked by the consequences of that necessity. That is, the structure of their work reflects their endeavor and the lack it signifies. In a place where art has no history, function or value, art cannot establish or take a critical or class position; any critique it attempts floats. As well, the necessity of making a scene, of creating their own institutions of support and distribution — their own and others' patronage so to speak — has infiltrated the work as a metalevel. More than ironical distancing, this "support structure" and metalevel at the same time, as an element of the enunciation of the work's discourse, collapse form and content together. Rather than a critique of support

structures and ideology in general, this has the tendency to raise the work in its entirety to the metalevel, a superstructural "support" that is *ideology itself*. General Idea's resort to ambiguity, the multiplicity of meanings, and an expanding system of verbal puns and paradoxes, all referenced to current theories of interpretation or textual reading, and their own self-referencing system reflect the form of capitalism they wish to criticize. In the end, do they accommodate us too readily to that reality without the means to show us what is real about it?

In accommodating us to that reality, the work directs us away from the contents of that experience to the forms of capitalist ideology. This tendency away from the real, however problematic the term "real," is the mutual point of my critique of General Idea and my comments on French theory (i.e., structuralism, semiotics, deconstruction), a critique of the construction of a theoretical model and the construction of "The 1984 Miss General Idea Pavillion," both of which substitute themselves for the real on an ideological level. The points I wish to make are that inhabitation is the creation of a formal system; that its effects are merely a formal operation; that it has a tendency to distance itself from the real in instituting its own operations as a system of value; and that consequently its critique reproduces the existing order that it attempts to subvert.

In discussing General Idea's work I shall concentrate on four issues of *FILE* and the work which corresponds to each. These are (1) the Fall 1975 "Glamour" issue; (2) the Summer 1978 "1984, A Year in Pictures" issue; (3) the

Fall 1979 "Transgressions" issue; and (4) the March 1981 "$UCCE$$" issue. In this way I want to show that the stylistic and conceptual set-up that seems to lead so "naturally," within its overdetermined cultural forms, from "Glamour" to "$UCCE$$" has not been founded on capitalism as a found object, the theme of the last issue, but that capitalism is the driving force of the work. The dependency on semiotics has consequences. Just as imperialism is "the highest stage of capitalism," so perhaps semiotics is capitalism's most thoroughly developed cultural form, capitalism at its most rationalized.

## 1. Glamour: Myth Mythifying Myth

The concepts behind the "Glamour" issue will set the basis for General Idea's future work. The model that institutes their general operation is Barthes' semiology. The model provides both the strategy and form for the work. This operation has two stages. It sets up a system which then formalizes itself. It institutes itself as a system and then maintains itself as a system. The first consequence of formalization is the loss of an original referent; the second is self-reference. Something is lost in formalization, namely history, in return for the construction of a self-history. Semiology/semiotics is used as a means of construction of General Idea's own self-referential system instead of analysis of myth. General Idea use it to create their own myth.

"Glamour" was General Idea's global sign of 1975 and

the subject of a special issue of *FILE*. *FILE* "megazine" of course is General Idea's parody, appropriation and inhabitation of *LIFE*, the American photomagazine. *FILE* duplicates *LIFE*'s picture-caption/commentary format, but turns it into a semiotic object for mythification in the reverse of *LIFE*'s role of ideological formation of mass consciousness. Or rather, it is not *LIFE* that is analyzed or deconstructed as much as its format and now ironical tone are lifted.

With this issue, immediately we encounter the problem of the proliferation of the editorial. The whole issue, or at least that devoted to General Idea, is an extended editorial. One could say that, like an extended metaphor, it is an allegory of General Idea's enterprise. The editorial enters into the whole production: it is a simulation. "All myth and no content. Or is it vice versa?"

Within that inhabitation of *LIFE* magazine is another story we all know:

This is the story of General Idea and the story of what we wanted.

We wanted to be famous, glamourous and rich. That is to say we wanted to be artists and we knew that if we were famous and glamourous we could say we were artists and we would be.

We never felt we had to produce great art to be great artists. We knew great art did not bring glamour and

fame. We knew we had to keep a foot in the door of art and we were conscious of the importance of berets and paint brushes. We made public appearances in painters' smocks. We knew that if we were famous and glamourous we could say we were artists and we would be. We did and we are. We are famous, glamourous artists.

Is this enunciation their "real" strategy and intention, or one statement within another strategy that is more properly the discourse and form of their art? Like conceptual art that asserts itself as art through the procedures of tautology, declaration or context, this language work declares itself: "we could say we were artists and we would be. We did and we are." Seemingly performative, this enunciation strategy is tautologous, a mirror image of itself, the mirage of a constitutive act if we do not accept its contract.

Both a format and a role are inhabited by General Idea. The format provides the vehicle for the elaboration of the role:

What is artificiality? We knew in order to be artists and to be glamourous artists we had to be artificial and we were. We knew in order to be artifical we had to affect a false nature, disguising ourselves ineffectually as natural objects: businessmen, beauty queens, even artists themselves.

The image of the artist is the easiest to inhabit. Because

of its historic richness, its ready but empty mythology (berets, paint brushes, palettes, in a word *FORM* without content) the shell which was art was simple to invade. We made art our home and assuming appearances strengthened by available myth, occupied art's territory. Thus we became glamourous, made art, made ourselves over in the image of art....

We are obsessed with available form. We maneuver hungrily, conquering the uncontested territory of culture's forgotten shells — beauty pageants, pavillions, picture magazines, and other contemporary corpses. Like parasites we animate these dead bodies and speak in alien tongues.

Thus forms are taken over; inhabitation is an operation. General Idea enunciate two strategic operations. One is "Stolen Lingo" which is a parasitic strategy of plagiarism: "We knew that in order to be glamourous we had to become plagiarists, intellectual parasites. We moved in on history and occupied images, emptying them of meaning, reducing them to shells." This other method is "Image Lobotomy": "Glamourous objects events have been brutally emptied of meaning that parasitic but cultured meaning might be housed there. Thus Glamour is the result of a brief but brilliant larceny: image is stolen and restored, but what is restored?" Its replacement instills ambiguity — meaning is solicited and then shaken: "A resonance which is ambiguity flips the image in and out of context. Layers

of accumulated meaning snap in and out of focus." Context and content alternate between being culture and nature, nature and culture.

The "object" of this? What is Glamour? It is myth.

An American literary modernism and postmodernism from Gertrude Stein to William Burroughs informs this work. So do French structuralism and semiology. With all the mention of the nature-culture interchange in the "Glamour" issue we might think of this structural signature of anthropologist Claude Lévi-Strauss. But with the naturalizing of what is historical, we more readily turn to semiology's popularization in the work of Roland Barthes.

Let's look at Barthes' essay "Myth Today" in his *Mythologies*, published in 1957 and translated in 1972. In this methodological afterword Barthes applied semiology not to objects far afield, as in the case of Lévi-Strauss's primitive societies and their myths, but to those objects and meaning systems close at hand: to movies and movie stars, sports events and pastimes, magazine articles, consumer products, etc. — to a whole "mythology" of everyday bourgeois life of petit-bourgeois ideological formation. Barthes made these "objects" culturally significant for the first time.

In one form or another we all know the theory of this book: it itself has become "naturalized" in our critical discourse. To reiterate, Barthes saw contemporary "myth" as a second-order semiological system:

In myth, we find again the tri-dimensional pattern

which I have just described: the signifier, the signified and the sign. But myth is a peculiar system, in that it is constructed from a semiological chain which existed before it; it *is a second-order semiological system*. That which is a sign (namely the associative total of a concept and an image) in the first system, becomes a mere signifier in the second. We must here recall that the materials of mythical speech (the language itself, photography, painting, posters, rituals, objects, etc.), however different at the start, are reduced to a pure signifying function as soon as they are caught by myth. Myth sees in them only the same raw material; their unity is that they all come down to the status of a mere language. Whether it deals with alphabetical or pictorial writing, myth wants to see in them only a sum of signs, a global sign, the final term of a first semiological chain. And it is precisely this final term which will become the first term of the greater system which it builds and of which it is only a part (pp. 114-115).

If Glamour equals myth, let's use Barthes' essay to explicate and throw some light on General Idea's term, myth and objet d'art. In "Stolen Lingo" when General Idea say "We knew Glamour was not an object, not an action, not an idea," Barthes adds "myth cannot possibly be an object, a concept, or an idea..." (p. 109). When General Idea continue "We knew Glamour never emerged from the 'nature' of things," Barthes too continues on myth that "it cannot possibly evolve from the 'nature' of things" (p. 110). When

144

talking of the mythified image Barthes writes: "if myth did not take hold of it and did not turn it suddenly into an empty, parasitical form" (p. 117), General Idea elaborates: "We knew that in order to be glamourous we had to become plagiarists, intellectual parasites. We moved in on history and occupied images, emptying them of meaning, reducing them to shells."

In "Objet d'Art," when General Idea unashamedly exclaim: "An object exhibits unashamedly a closure and a brilliance, in a word a SILENCE which belongs to the world of myth," Barthes has "anticipated" them in saying: "Every object in the world can pass from a closed, silent existence to an oral state..." (p. 109). Here General Idea seem to reverse Barthes, except that "Glamourous objects open themselves like whores to meaning, answering need with vacancy, waiting to be penetrated by the act of recognition."

In "Gestures," General Idea tell us that objects are related to gestures: "This sign is repeated endlessly, becomes thick with accumulated meaning. The gesture becomes raw matter for myth." Barthes tells us what to make of General Idea's gesture: "This repetition of the concept through different forms is precious to the mythologist, it allows him to decipher the myth: it is the insistence of a kind of behaviour which reveals its intentions" (p. 120).

When in "Artificiality," General Idea tell us that they "are obsessed with available form. We maneuver hungrily, conquering the uncontested territory of culture's forgotten shells," Barthes explains myth and General Idea: "But

in general myth prefers to work with poor, incomplete images, where the meaning is already relieved of its fat, and ready for a signification, such as caricatures, pastiches, symbols, etc." (p. 127).

In "Image Lobotomy," General Idea continue parasitically on the parasitic: "Glamourous objects events have been brutally emptied that parasitic but cultured meaning might be housed there. Thus Glamour is the result of a brief but brilliant larceny: image is stolen and restored, but what is restored? Memories are blurred. Details have been erased. The image moves with the awkward grace of the benumbed, slave to a host of myths." Barthes: "This is because myth is speech *stolen and restored*. Only, speech which is restored is no longer quite that which was stolen: when it was brought back, it was not put exactly in its place. It is this brief act of larceny, this moment taken for a surreptitious faking, which gives mythical speech its benumbed look" (p. 125). And again General Idea: "A resonance which is ambiguity flips the image in and out of context. Layers of accumulated meaning snap in and out of focus. Myths hide behind the mask of 'real' images; the shifty eyes of cultural content watch through the loopholes of natural context." Barthes: "I shall say that the signification of the myth is constituted by a sort of constantly moving turnstile which presents alternately the meaning of the signifier and its form, a language-object and a metalanguage, a purely signifying and a purely imagining consciousness" (p. 123). "And that is Glamour." And yet, as Barthes adds, "reality stops the

turnstile revolving at a certain point" (p. 123).

Perhaps this policing exercise does not explicate "Glamour" as much as throw some light on General Idea. For what is "Glamour" after all but a vehicle for building the myth of General Idea. It does not have to be consistent, name a referent, or mean anything: it has a pure sign function of zero symbolic value. And yet, speech stolen and restored does not seem to give us as much as the "original" here in the analysis of an object: its surreptitious faking is benumbed. In terms of effectivity, it effects itself. That determines whether we are interested or not; it is a matter of interest or investment, a stock in General Idea.

Barthes also introduces and explains three concepts that in turn will structure General Idea's enterprise. These are *metalanguage, appropriation* and *artificial myth*. This, however, does not make General Idea's dependency negative and Barthes' critique positive. Barthes' drift from the social, political position of "Myth Today" cannot be left uncommented.

Barthes says that myth is a second-order semiological system. "It can be seen that in myth there are two semiological systems, one of which is staggered in relation to the other: a linguistic system, the language (or the modes of representation which are assimilated to it), which I shall call the *language-object*, because it is the language which myth gets hold of in order to build its own system; and myth itself, which I shall call *metalanguage*, because it is a second language, *in which* one speaks about the first" (p. 115). Barthes also will call the two denotation and con-

notation respectively. He immediately goes on to write: "When he reflects on a metalanguage, the semiologist no longer needs to ask himself questions about the composition of the language-object, he no longer has to take into account the details of the linguistic schema; he will only need to know its total term, or global sign, and only inasmuch as this term lends itself to myth" (p. 115).

What happens to the "original" object or sign system? How is it reconstituted? Or is it lost altogether in the formalization of the system? In effect, through an analysis the semiologist produces a third-order semiological system. This also is the operation that institutes General Idea's art and constructs the "Pavillion" as well. But in this process, in Barthes and General Idea, what is lost sight of, and what process is repeated in the loss of detail to the global? General Idea's work basically is a third-order system, developed from semiology and built up from a self-referring and proliferating discourse that they instituted themselves. What starts out as material for the second-order system is emptied by myth; what starts out as material for the third-order system of General Idea's art — *LIFE* magazine, popular culture formats, etc., i.e., the language-object — in turn is forgotten in favour of the system itself, as the functioning of the system. It is at a third remove from the "real." Was there ever an original object we may ask? If a system of connotation takes over the signs of another system in order to turn them into its own signifiers, we may find that General Idea's is not a system of connotation at all, not a mythology, but a myth on another order. Their

work follows the tendency towards the disappearance between language-object and metalanguage that we also find in Barthes. Metalanguage becomes its own primary (performative) language — language-object and language in one: a textual system. The history of this system and the story of General Idea become the function and maintenance of the system. Moreover, its formal reproduction and expansion extend temporally forwards and backwards. It can accommodate itself to anything that is in the air, or to any revision: "Glamour is the perfect simulation for ongoing battles, the perfect tool for shaping history: adding, substituting, indeed MAKING history."

Since the audience is captured by this self-referential and therefore closed system whose discourse is out of their control (they can learn it and thus participate in a manner by their consumption), since the audience is arrested in this manner, General Idea can maintain the basics of the system and add new product lines occasionally, just like General Motors.[5] The original referent was lost long ago in this specular play of reflecting images. Not only does it mimic myth, their work repeats it on a higher, more sophisticated level. That is, it fetishizes the mythic process rather than demystifies it.

Semiology repeats the fundamental character of myth: appropriation: "In this sense, we can say that the fundamental character of the mythical concept is to be *appropriated*" (Barthes, p. 119). But myth undergoes the same fate under the gaze of the mythologist. Whereas in myth it is the concept or the image that is appropriated, for semiol-

ogy it is the form and for General Idea the format. Contrary to myth which saturates the image in a naturality that disguises this political act, the operations of appropriation in semiology and General Idea are openly given a political character. "Glamour replaces Marxism as the single revolutionary statement of the twentieth century." In other words:

> It thus appears that it is extremely difficult to vanquish myth from the inside: for the very effort one makes in order to escape from its stranglehold becomes in its turn the prey of myth: myth can always, as a last resort, signify the resistance which is brought to bear against it. Truth to tell, the best weapon against myth is perhaps to mythify it in its turn, and to produce an *artificial myth*: and this reconstituted myth will in fact be a mythology. Since myth robs language of something, why not rob myth? All that is needed is to use it as the departure point for a third semiological chain, to take its signification as the first term of a second myth (Barthes, p. 135).

Metalanguage becomes artificial myth through appropriation.

In metalanguage, appropriation and artificial myth, we have General Idea's procedures in a shell, the operant language for the rest of their work (as a structure: metalanguage; a method which is its content: appropriation; and a presentation: artificial myth). The tendency of the work repeats myth: as a process of structuring away from the

real; which institutes itself as a system of value, rather than fact; and which in turn is justified by reference to its "object." In order, these raise the issues of reification, capital and simulation.

Taking inhabitation at its word, what is the relation between the content (meaning) emptied from the format and the content, not restored, but inserted into the "same" format — called "cultural content" or "cultured meaning" by General Idea in "Image Lobotomy"? We can only take the new content to be what is given, what is said by General Idea, and that is the announcement of a strategy. Already this strategy seems to be working on the level of a critique rather than content: in that case it is formal. There is no clear form-content dichotomy because there is only form ("in a word FORM without content"). And what is the effect? Content is not substantiated, effected or effective in any way. It is a method that is effected, that is, instituted as a structure. The effect of the method is the same as the enunciation of the strategy, which is to say there is no critical effect. To say that content here is in any way effected is to fetishize it, turn it into a form: "All myth and no content? Or is it vice versa?"

Content then is an enunciated operation that effects itself formally. We could say that one formal operation of signs is inserted into another, which is the format of what is being "inhabited." When General Idea empty the "content" and insert their own, can this still be the same form or object? Yes, only insofar as it remains formal. Exchanging signifiers by this operation of substitution restores or

reproduces the code. Once more the referent is lost in the play of the signifiers of the system. But the referent was never there. *FILE* only has the *superficial appearance of LIFE*. Signifiers are not exchanged; a formal system of signifiers is constructed through this enunciation process which tells us something else. Metalanguage is its own object. It constructs itself and tells us about it at the same time. Its content is this formal process of self-referentiality, not an analysis or description (General Idea tells us they do not want to describe, they want to be critical). The effects actually take place within a language convention. This is a learned language with a constituency or audience whose competency can register the "effects," "transgressions" and displacements within the conceptual, textual structure, a structure that has been designed. It is never a critique, only the announcement of an intentional affect.

## 2. The Chain Gang: Maintenance Work on the Pavillion

The repository of the "acts" or image of "Glamour" is the "Pavillion." The "Pavillion" is constructed from fragments of myth, like Lévi-Strauss's *bricolage*. Myth is a system of value: there is no adequation between it and the real. Barthes confirms: "any semiological system is a system of value; now the myth-consumer takes the signification for a system of facts: myth is read as a factual system, whereas it is nothing but a semiological system" (p. 131). Yet, in a

way that Barthes' own career did not confirm, because a textual "revolution" took place, "reality stops the turnstile [or General Idea's venetian mirrors flipping the image in and out of context, we might add] revolving at a certain point. Myth is a *value*, truth is no guarantee for it; nothing prevents it from being a perpetual alibi: it is enough that its signifier has two sides for it always to have an 'elsewhere' at its disposal" (p. 123). "The 1984 Miss General Idea Pavillion" is a spatialization of this metaphor, although it does not have to appear in space. Except for the "Pavillion" there is no one place which is true or full and the other artificial or absent — it is all simulation. The "Pavillion" is that perpetual alibi in process.

Having instituted itself as a system, it now maintains that system. But it has to dissolve the levels between language-object and metalanguage. The "Pavillion" itself becomes that site of discourse: the "Pavillion" is a textual system. As "defining the limits of the project," take the example of the *Hoarding*, exhibited in front of the Carmen Lamanna Gallery in 1975 and described in *FILE* (Summer 1978), "1984, A Year in Pictures" as well as in a videotape. It is everywhere, that is, "decentered":

> Traditionally you would call it de-centralized but we see it as "widely centralized." We never refer to the sites of the Pavillion. Only the site. It's a singular site with multiple points of view. The fact that there are several locales where activity takes place only expands the centre. Our centre is defined by the circumference and the

Hoarding is a sort of tool that allows us to expand the centre to any of its installations.

It has no referent other than its own construction:

> …the Hoarding stands entirely on its own and has nothing to hide. You can see it on the surface, you can see around it and you can even see through it. There's nothing more to it than meets the eye.

And it is composed of a string or chain of signifiers, a pure fabrication that does not need a referent or content, as is said of "The Miss General Idea Vehicle":

> We've tried to underline the fact that there is nothing behind it. No verso to speak of. The task of stringing together enough evidence to present this case is a labour of pure fabrication.

Because it is a system of value, signifiers can exchange among themselves outside of any relation to a referent. As Jean Baudrillard has written, it is precisely because they do not exchange against the real that they can exchange among themselves. The model of floating value is of course capital.[6]

All referential value is lost in the structural play of value. This structural dimension autonomizes itself to the exclusion of the referential dimension. In its autonomy the system itself is a fetish. This tendency away from the

real creates and valorizes a closed system: the fetishized "Objet d'Art" of "Glamour." A commentary on the fetish, it is a fetish itself, not an object, but a system. A system may be closed while appearing telescopic or expansive, an empty frame projecting into a seeming spatial or temporal structure:

> THE FRAME OF REFERENCE is basically this: a framing device within which we inhabit the role of the general public, the audience, the media. Mirrors mirroring mirrors expanding and contracting to the focal point of view and including the lines of perspective bisecting the successive frames to the vanishing point. The general public, the audience, the media playing the part of the sounding board, the comprehensive framework outlining whatever meets their eye.

"Ideological discourse," Baudrillard writes, "is also built up out of a redundancy of signs, and in extreme cases, forms a tautology. It is through this specularity, this 'mirage within itself,' that it conjures away conflicts and exercises its power."[7]

This system, however, always entertains and encounters a crisis: it is always close to death in its perfection. But this crisis is not destruction. Destruction enters the system as its mirror image. For construction, there is destruction, and for composition, decomposition: the "Pavillion" was "destroyed" in 1977.[8] These are only terms of absolute exchange: interchangeability and reversibility, which can

only occur in a formal system. Destruction only opens a new possibility of exploitation. In *Reconstructing Futures*, "General Idea were forced to assume new careers as archaeologists as they sifted through the rubble attempting to locate the many missing and presumed lost pieces."[9] This destruction can be accommodated as the mirror image of the project, its absolute reversibility, what is always already inscribed in the logic of the system. In this destruction there is no change of form and its content is changed only insofar as the source has changed, and insofar as this source has become a new model of enunciation. Reconstructing futures is a framework and process for maintaining the system in its seeming changes (according to the demands of the time, a change of appearance, not model, i.e., fashion), to enable it to keep open to the possibility of new objects on the order of archaeology (I could say capitalism instead). Reconstructing futures is an archaeology in reverse, excavating future images from the recent past; that is, its subject is myth. That is the image; there is the caption as well. Archaeology for General Idea is only another word for self-reference.

*FILE* "1984, A Year in Pictures" then is one manifestation of the "Pavillion," and the "work" on it. While this issue catalogues ten years of General Idea's work and thus is at a lag with their then current work, the editorial which is of the moment announces a "crisis." We know that that crisis for them was not the crisis of reversibility. Rather a text is pulled into crisis: "The nature of criticism, like the nature of puns, is to pull a 'text' into crisis. The nature of

our work then is 'critical,' as opposed to descriptive," say these "hard-core post-Marxist theoreticians." "We wanted to point out the function of ambiguity in our work, the way in which ambiguity 'flips the meaning in and out of focus,' thus preventing the successful deciphering of the text (both visual and written) except on multiple levels. Curiously, many of you choose only to read one side to any story. Since we give a wide range of choices (and we are conscious of the politics of choice) we are never sure which side you, our readers, will take."

Under the name of plurality: "We do it all for you" — the indexes of advertising. Consume the multiple levels of ambiguity of General Idea. There is always another interpretation or product to "capture" you — "You — You're the One." Multiplicity and ambiguity, flipping the image in and out of focus, moving the turnstile, in other words, consumption enters the infrastructure. Capitalist production and consumption model the process of meaning and its structuring.

What is this text and its crises? There are two or three disruptions which become critical for General Idea. They are a secret crisis for them not only because their sources but the whole manner of their rhetoric of enunciation change. We shall find that the crisis of the text is also a secret continuity. 1957 meets 1972 in 1977. And here we meet the problem of translation and dissemination. What was an historical trajectory in the hands of a few French writers (Barthes, Derrida, Deleuze) offers itself all at once in translation. Barthes' text "Myth Today" published in

1957 is translated in 1972 (*Mythologies*), the year that Deleuze and Guattari's *Anti-Oedipus* is published in France only to wait until 1977 for its translation. Barthes' other texts were being translated as well as Foucault's and they were all available for exchange at the end of the decade.[10]

One disruption enters to inflect the editorial: Barthes' adoption of a Textual theory over semiotics. One consequence is the destruction of metalanguage by textual activity, but General Idea had already accomplished that.[11] The other is the text's plurality: "the multivalence of the text, its partial reversibility."[12] This disruption affects the text of General Idea's writing. The others will effect the social "text" of their work — the irruption of the body through Foucault's later writing and the fortuitous subject-group in Deleuze and Guattari.

The crisis is the transformation that the crisis, or the concept of crisis demands. The crisis is the seeming transformation from a closed system to anarchy. Desire liberates itself from the closed system of the fetish object to anarchy, from the objet d'art to the social body in flux. The crisis, however, is only symptomatic of the system: it does not come from outside anymore than reversibility did. The fetishized object disguises the system which is the fetish itself. The system in fact operates this other "fetish" (the object or subject) as a nodal point, as a symptom. The system can accommodate this new irruption, or adoption and insertion, because it chooses to initiate a new economy of force.

Returning a year to 1977, to the "Punk 'til you Puke"

issue of *FILE*, an article by AA Bronson, "Pogo Dancing in the British Aisles," initiates all the themes and strategies that will have to be integrated into General Idea's structure. No problem: they are the system at its most intensive. We are introduced to the themes: desiring anti-capitalism; anarchy; the group; and desiring machines.[13] We move from questions of ideology to those of productivity; from the general ideology (myth) of Miss General Idea to that of the practice of the trio General Idea; from ideology/myth to the material productivity of the group. These of course are the themes of *Anti-Oedipus*, that infectious book of 1972, disseminated in North America in translation in 1977 and through subsequent issues of the journal *Semiotext(e)*.

It is impossible to discuss the issues devolving from that article and its borrowings from *Anti-Oedipus'* tool-box. All I can do is point out the rhetorical ease with which the anti-family, anti-hierarchy, anti-representation of the homosexual group appear and replace a whole political debate with each term. If we can measure the effectivity of these terms in political action, how do we account for the assimilation of a theoretical textual model to gay erotics (or erotics in general) when for General Idea this ends in the "dog eat dog eat dog" language of their poodles, the image of their current work? Not even good taste is transgressed here.

Political economy has become acquainted with a libidinal economy on the authority of a textual theory. A new semiotics bases itself not on linguistics but on the symp-

tomatic condensations and displacements of the unconscious (Freud/Lacan) and the death drive (Lyotard). From the text we leap to the "social text." A crisis is exposed in the social body, first on the model of the psychoanalytic unconscious, and then on the model of the productive anti-Oedipal unconscious, on the schizo and desiring machines. What has been taken as a formal operation within the text, in the "production" of the text, is projected onto the concrete real in order to implicate contradictions of that order there. The world is made into a text in order to read symptoms there, which is another way to say that the real does not exist. This is an imposition of a language strategy, not an analysis. Formal "revolution" presumes to lead to political revolution (at least within these relative spheres of choice: sexuality, etc.). One has done ones duty in theory, if not in practice. A language operation has taken for itself the value of political action. But what do these operations within the text implicate in its utopia of infinite productivity and interchangeability other than a capitalist authority, process and strategy?[14]

What is projected into the social realm — desire — is returned to the subject of the audience as symptomatic and disruptive affect/effect. The subject is only a subject-effect, a symptom as much inhabited as it is a disruptive relay in the network of desire. Ideological critique and inhabitation come together here. Each presumes an effect, and for both the individual is only a position or a subject within a system of effects. (The system both analyze is also the system both impose on the subject.) Ideological critique:

that ideology effects (arrests, captures, interpellates) the individual as a subject — a form effecting the contents of consciousness by the very constituting of subjecthood. Inhabitation: that its formal processes (changing the contents of an inhabited form) have a disruptive critical effect — the subject is an affect, a subject-in-process that can be formally disrupted. Here contents seem to be displaced from consciousness to the material body — the symptomatic body composed by desire.

The body in fact now becomes a signal-theme. Text equals body, and both are productive machines. So the body, its cutting up, fetishizing and framing, its surveillance, familial — Oedipal — restraints (the cutting up of sexual drives) become the themes of General Idea's "Consenting Adults" exhibition of 1979. But the display of work like *An Anatomy of Censorship*, *Autopsy* and *Geometry of Censorship* only signal the breakdown of structure and superstructure (of ideology and repression on one hand and the subject on the other) in the levelling of differences in the production of desire. It does not matter that organs are differentiated, repressed or exposed here: they are set into motion as a system of interchangeability.

*Semiotext(e)'s* "Schizo-Culture" issue of 1978 informs, more than liberates this discourse. So do the notions of surveillance and power in Foucault's interview "The Eye of Power" published in that issue, as well as the study of the political technology of the body of his *Discipline and Punish* (1975; trans. 1978), and the analysis of the intensification and proliferation of discourses on sexuality of his *History*

*of Sexuality* (1976; 1978) contribute to the shift of focus in the frame of reference. This "schizo" period, reaching its peak of dissemination in North America in the late '70s, was symptomatic of the intensification of capitalism's effects in its crises of the '70s (reaching its full economic and concrete political effects around 1980). While its theoretical and ideological effects had been loosed earlier, it is the present political effects that allow this analysis now. The structure perhaps was only rearticulating itself. Desire's weakening of the superstructure Bronson indicated in "Pogo Dancing" only served to generalize the *capitalist* code of desire at all levels.

This crisis of disorder will be resolved by a return to order (not yet the notorious "re-materialization of the art object" announced in *FILE* in 1981). It will be resolved by a return to form, a return to the format. The crisis is to be resolved by "effectivity." Punk is just another format. This return to order is a "pragmatic anarchy" as the editorial to the Punk issue of *FILE* concludes. What Punk means here is that inhabitation is effectivity and effectivity is anarchism, i.e., critical disruption. But it is also an audience: "Obviously art that has effect is art that has an audience." And it will lead to success in the market.

## 3. Transgressions in the Marketplace

We never dispute that order in the elegance of General Idea, and their restraint. What could be more elegant and

restrained than transgression? And what could be more responsible than trendiness: "These days a friend visiting General Idea is likely to be served a new drink — 'trendy responsibility'; a ratio, a balance, a borderline case, one of the many effective cocktails available at General Idea's newly opened Colour Bar Lounge...Yes, 'trendy' is a word to be grappled with, as 'glamour' once was," the editorial for the special "Transgressions" issue of *FILE* (Fall 1979) says.

Transgression, then. On the one hand, transgression is another form of inhabitation leading to effectivity. The locale of this inhabitation is no longer just a format, but a location of activity: at the limit. No longer is the body just symptomatic: it is perverse. On the other hand, transgression seems to be merely a matter of choice. The limit then is within, not at the edge.[15] "Mix together a few of the ingredients found on the following pages — we call them transgressions. Cultural, social, political, sexual, take your pick." This mere choice is effective: "Certainly there is one peak moment when trendiness rises to its most effective, when it becomes a powerful tool for dealing with existing structures. It blooms for a night or a season, and then is consumed by what many call Capitalist chaos." This generalization of every level and distinction (as in the article "Pogo Dancing") to a matter of choice is not a tool for dealing with existing structures; it is a tool of those existing structures: capitalism. What General Idea express for the edge, "transgression," operates and reproduces itself in the centre as *choice*; and the centre reproduces it-

self on the edge in expansion (i.e., appropriation), which remains in the interior (e.g., the *Hoarding*) — captured, capturing. What is transgression but a matter of choice of what is offered: just one more discoverable, marketable and consumable position within a system of structured oppositions: dual: fascism-anarchism; multiple: sexual organs-orifices. For whatever — drinks, sex, ideologies, theories — mix and match. Whatever your taste, the system supports it, having created its possibility. You *are* capitalism's "test tubes."

General Idea has chosen the highest form of capitalism, the multinational corporation, as a model for their art. Their own form of parasitic imperialism, appropriation, expands itself through an enunciation strategy similar to imperialism that expands itself on the basis of the export of capital rather than commodities. All the same, the realization of value bases itself on the structure of the commodity. But General Idea are also entrepreneurs.[16]

The editorial asks: "And what name shall we give to that distance that separates the trendy from the avant-garde?" General Idea answers, always be ahead of that "Capitalistic chaos": "a responsible trendy is never consumed. S/he is consummated. Letting oneself be consumed is sheer irresponsibility, like developing a drinking problem. Our role? Like customs agents on the borders of acceptance, we smuggle transgressions back into the picture, mixing doubles out of the ingredients of prohibition." Restraint, manipulation, the format. Is one fooling oneself in thinking that one is ever ahead when the process itself is capi-

talistic? General Idea are not customs agents but active importers — the advance guard of a national capitalism in their transvaluation of value through *FILE* magazine and their work. On that seeming border which is a line of words within their own system, like merchant middlemen, they weigh value against value; and they are responsible for the change of value through the furthering of a system of value. They are purveyors of choice, with products as values and values as products, within the limits of the structural and systemic model that is here the art world. They really are the business men they play and say they are.[17]

## 4. Capitalism as Found Objects: Money Talks

We must get into the habit of paying strict attention to precisely what the fascist has to say and not to dismiss it as nonsense or hogwash.

In talks with the followers of the National Socialist party and especially with members of the SA, it was clearly brought out that the revolutionary phraseology of National Socialism was a decisive factor in the winning over of these masses.

Wilhelm Reich

One of the lessons which Hitler has taught us is that it is better not to be too clever.... There is a historical ten-

dency for cleverness to prove stupid. Reasonableness in the sense which Chamberlain called Hitler's demands at Bad Godesberg "unreasonable" is all very well if the balance of give and take is respected. Reason is based on exchange. Specific objectives should only be achieved, as it were on the open market, through the small benefits which power can obtain by playing off one concession against another and following the rules of the game. But cleverness becomes meaningless as soon as power ceases to obey the rules and chooses direct appropriation instead. The medium of the traditional bourgeois intelligence — that is, discussion — then breaks down.

<div align="right">Max Horkheimer and Theodor Adorno</div>

FASCISM AND ANARCHY JOIN FORCES TO CREATE A WORK OF ART: "The 1984 Miss General Idea Pavillion was the first concrete manifestation of that uneasy union we now take for granted, the first project where fascism and anarchy could join forces to create a work of art — and they did."

<div align="right">General Idea[18]</div>

With the juxtaposition of the above quotations and the demand for work at its word, rather than formal work on the word, a demand for "crude thinking," I may be mistaken in falling into the trap of taking a textual system for communication, or a formal apparatus for political rhetoric. Does art claim different criteria for judging its state-

ments within its own frame when at the same time it claims a critical effectivity, a critical disruption of forms and consciousness which therefore is a political act? Horkheimer and Adorno identify another sense to the word "appropriation." When things are not taken at their word, what type of aesthetic system does that signify, and, more importantly perhaps, what type of social place for art? It is my belief, and not only my belief, that something changed socially and politically in 1980 as a culmination of the economic crises of the '70s; that the strategies that were theoretically "correct" in the middle to late '70s and that could circulate without referential consequence are no longer applicable today; and that their pursuit turns them into exactly the opposite: radical art legitimizing the accepted order.

Where does this leave us with General Idea? There is the *FILE* editorial for the "$UCCE$$" issue. Published in March 1981, it seems to recognize the change in political climate. "WE BELIEVE: Reagan's recent budget and Toronto's police raids are signals to the left from the right to occupy battle positions, assume territorial stances (oh, the old routines) and act out the importance of being earnest." But we know that there is no single position for General Idea, recognizing the Anti-Oedipal irony of this statement and remembering "The Battleground" and "battle stances" of the "Glamour" issue where "Glamour replaces Marxism as the single revolutionary statement of the twentieth century." "Post-Marxist" and never "earnest," General Idea "mobilize gossip columns against

fascism in BZZZ BZZZ BZZZ."

There is the editorial, and then there is the specular identity of their objects. Money recognizes money in a formal tautological system: "Approach success as being reflexive and cash-referential." When we come to the products, to the "re-materialization of the art object," in an object like the dollar sign *Liquid Assets* (1980), part of *The Boutique from the 1984 Miss General Idea Pavillion* (1980), which sells products as much as it sells General Idea's system (*FILE*, etc.), do we really need to continue the analysis or is this specular tautology enough? In the objects as much as in the system we have an image at its word.

General Idea's videotape *Test Tube* (1979-80) recapitulates all the themes of inhabitation of their earlier work. "Think of capitalism as another format we can occupy and fill with our content," says Jorge in the "Colour Bar Lounge." From myth, we end in capitalism. And we find that effectivity actually does equal capitalism. And if we could say earlier about myth and inhabitation that the operation that General Idea employed was a formal operation that repeated myth; what can we say of the inhabitation of capitalism as a found format: that in mirrors mirroring mirrors, General Idea have discovered their tautology, image and fetish in capitalism?[19]

*Notes*

1. Friedrich Nietzsche, *Daybreak*, trans. R.J. Hollingdale (Cam

bridge: Cambridge University Press, 1982), sect. 523, p. 208.

John Willet, trans. and ed., *Brecht on Theatre* (New York: Hill and Wang, 1964), p. 106.

This article was originally delivered as a lecture entitled "Sentences on Art" in the YYZ (Toronto) "A Critical Structure(ing)" series, November 22, 1982.

2. Pierre Bourdieu discusses investment in a formal system of value, in his case the philosophical institution, which is applicable here: "In the beginning is the *illusio*, adherence to the game, the belief of whoever is caught in the game, the interest for the game, interest *in* the game, the founding of value, *investment* in both the economic and psychoanalytic sense. The institution is inseparable from the founding of a game, which as such is arbitrary, and from the constitution of the disposition to be taken in by the game, whereby we lose sight of the arbitrariness of its founding and, in the same stroke, recognize the necessity of the institution.... The most fundamental reasons for acting are rooted in the *illusio*, that is in the relation, itself not recognized as such, between a field of play and a habitus, as that sense of the game which confers on the game and on its stakes their determining or, better, their motivating power. The arbitrary founding of value and of sense, an arbitrary founding which is unaware of itself as such and which is lived as the submission to a natural necessity or to universal values, *illusio*, investment, involvement, interest, all these are products of the logic of a field and serve, in turn, as the condition of its functioning. The establishment of history in things and in bodies causes the body politic, like the biological body, to be inhabited by a sort of tendency to persevere in its state of being, and to place individuals in the service of its own production." Pierre Bourdieu, "The Philosophical Institution," in Alan

Montefiore, ed., *Philosophy in France Today* (Cambridge: Cambridge University Press, 1983), pp. 1, 3.

3. Appropriation quotes or parodies other cultural or popular discourses, codes, styles or production techniques within a high art discourse and institutionality. See Benjamin Buchloh, "Parody and Appropriation in Francis Picabia, Pop and Sigmar Polke," *Artforum*, 20:7 (March 1982), pp. 28-34; and "Allegorical Procedures: Appropriation and Montage in Contemporary Art," *Artforum*, 21:1 (September 1982), pp. 43-56.

Inhabitation parasitically assumes cultural forms or codes, empties them of their "content" and by inserting its own effects a critical disruption. The usual site inhabited is mass media in its ideological formation of mass consciousness. Through the mass media, capitalism in general is critiqued. In "Allegorical Procedures," Buchloh writes: "In *Mythologies*, 1957, Roland Barthes deconstructed such contemporary myths as designed objects of consumption and advertising. In certain respects this can still be considered as the originary model for the deconstructive approach of the criticism of ideology as it has been developed in the work of the artists analyzed here," p. 56. Deconstruction has been aligned to early themes of appropriation. But while Barthes' early writing introduced the strategy of appropriation, it is his later writing of the '70s that lend terms of discourse to a strategy of inhabitation. For example: "He used to think of the world of language (the logosphere) as a vast and perpetual conflict of paranoias. The only survivors are the systems (fictions, jargons) inventive enough to produce a final figure, the one which brands the adversary with a half-scientific, half-ethical name, a kind of turnstile that permits us simultaneously to describe, to explain, to condemn, to reject, to recuperate the enemy, in a word: *to make him*

*pay....* He was astonished that the language of capitalist power does not constitute, at first glance, such a systematic figure (other than of the basest kind, opponents never being called anything but 'rabid,' 'brainwashed,' etc.); then he realized that the (thereby much higher) pressure of capitalist language is not paranoid, systemic, argumentative, articulated: it is an implacable stickiness, a *doxa*, a kind of unconscious: in short, the essence of ideology.

"To keep these spoken systems from disturbing or embarrassing us, there is no other solution than to inhabit one of them." Roland Barthes, *The Pleasure of the Text*, trans. Richard Miller (New York: Hill and Wang, 1975), pp. 28-29; and:

"To act as though an innocent discourse could be held against ideology is tantamount to continuing to believe that language can be nothing but the neutral instrument of a triumphant content. In fact, today, there is no language site outside bourgeois ideology: our language comes from it, returns to it, remains closed up in it. The only possible rejoinder is neither confrontation nor destruction, but only theft: fragment the old text of culture, science, literature and change its features according to formulae of disguise, as one disguises stolen goods." *Sade/Fourier/Loyola*, trans. Richard Miller (New York: Hill and Wang, 1976), p. 10.

Appropriation and inhabitation are thus seen to be the artistic component of a general ideological critique which in return lends art, which can disguise itself, its value as well as its form and strategy. The site and strategy are given further textual and philosophical justification in Jacques Derrida's "deconstruction":

"Our discourse irreducibly belongs to the system of metaphysical oppositions. The break with this structure of belonging can be announced only through a *certain* organization, a certain *strategic*

arrangement which, within the field of metaphysical opposition, uses the strengths of the field to turn its strategems against it, producing a force of dislocation that spreads itself throughout the entire system, fissuring it in every direction and thoroughly *delimiting* it." Jacques Derrida, *Writing and Difference*, trans. Alan Bass (Chicago: University of Chicago Press, 1978), p. 20; and:

"The movements of deconstruction do not destroy structures from the outside. They are not possible and effective, nor can they take accurate aim, except by inhabiting those structures. Inhabiting them *in a certain way*, because one always inhabits, and all the more when one does not suspect it. Operating necessarily from the inside, borrowing all the strategic and economic resources of subversion from the old structure, borrowing them structurally, that is to say without being able to isolate their elements and atoms, the enterprise of deconstruction always in a certain way falls prey to its own work." *Of Grammatology*, trans. Gayatari Spivak (Baltimore: Johns Hopkins Press, 1974), p. 24.

4. Roland Barthes, "Myth Today," in *Mythologies*, trans. Annette Lavers (New York: Hill and Wang, 1972), p. 124. Further references in the text.

5. Barthes talks of myth as an arrest of an audience: "It is turned towards me, I am subjected to its intentional force, it summons me to receive its expansive ambiguity" (p. 124); and of the concept: "The appropriation of the concept is suddenly driven away once more by the literalness of the meaning. This is a kind of *arrest*, in both the physical and legal sense of the term..." (p. 125).

General Idea have no difficulty recruiting others to their enterprise. It is the imposed inability to stand outside their work as much as the challenge issued in the following quotation that provoked the

response of this lecture/article. In discussing General Idea's enterprise through their name, one writer states:

"The paradox built into the name exists throughout the work of General Idea and is there to subvert any art historian or critic who might wish to take the upper hand and decipher General Idea's work. They have thought of all possible interpretations and built them into the work. Acting as corporation, architects and engineers, General Idea have materialized, manipulated and controlled what was 'in the air.' They are the originators and theoreticians of their own identity and projects. Ambiguity, paradox and irony have given them an image as impenetrable as that of a mega-corporation." Elke Town, "General Idea," *Fiction* (Toronto: Art Gallery of Ontario, 1982).

Apart from the interest to be given to the question of the author, the copyrightable proper name, implied in their working procedures and their corporate name, what strikes me about this passage is the sweep of assurance: not only the presumption of maintaining control over all possible interpretations — producing all the dangers of a closed system; but also the nonchalance by which this system is able to absorb all that is of contemporary, fashionable, critical value — all that is "in the air," picking up what is in the air, capitalizing on its currency, to the degree that this system is in the "air," as the meta-language that composes the structure of General Idea's art. And within this all-consuming, quasi-capitalist system, it is the metaphors that disturb — metaphors presumed to give General Idea's enterprise its "critical" edge: those metaphors of business tending to imperialism: the impenetrable image of the mega-corporation (i.e., multinationals). We know from General Idea that the impenetrable image is a fetish and from Marx that this fetish is capital. General Idea have chosen the highest form of capitalism, the multinational corpora-

tion, as the model for their art. Their own form of imperialism is appropriation and inhabitation that expands itself through an enunciation strategy.

Since they control the discourse, every interpretation rebounds in these sophisticates' favour. Every mention is more column inches in the construction of "The 1984 Miss General Idea Pavillion" and the "myth" of General Idea. But by naively taking them at their word, it is the challenge — the glove of the "Hand of the Spirit" so to speak — that General Idea, and not the catalogue writer, throws down here, that I take up: namely, their "subversion" of any critic who might wish to take the upper hand in deciphering their work. Maybe they *have* thought of all possible interpretations and built them into their work. Then their work is manipulation itself.

6. It is no accident that semiology like capital (and myth) is a system of value. When Saussure tried to revolutionize linguistics he used the example of money to explain the value system of linguistics. In money, a piece of coin can be exchanged against something of real value (use value); on the other hand it can be put into relation with all the other terms of the monetary system (exchange value). It is the latter case for which Saussure reserved the term "value" for language: the internal relativity of a general system of distinct oppositions, of all terms among themselves. And this is set up and valorized against the other possibility as designation (reference) or the relation of a signifier to its signified. It is also no accident that commodity reification has extended to the level of signs, or that production has become a signifying system. Baudrillard calls this "the structural revolution of value"; and it is capital that commands all the actual strategy of this system: "Ce n'est pas LA révolution qui met fin à tout cela. C'est le capital lui-même. C'est lui qui abolit la détermina-

tion sociale par le mode de production. C'est lui qui substitue à la forme marchande la forme structurale de la valeur. Et c'est elle qui commande toute la stratégie actuelle du système." "Cette révolution consiste en ce que les deux aspects de la valeur, qu'on a pu croire cohérents et éternellement liés comme par une loi naturelle, sont désarticulés, *la valeur référentielle est anéantie au profit du seul jeu structural de la valeur.* La dimension structurale s'autonomise à l'exclusion de la dimension référentielle, elle s'institue sur la mort de celle-ci. Finis les référentiels de production, de signification, d'affect, de substance, d'histoire, toute cette équivalence à des contenus 'réels' qui lestaient encore le signe d'une sorte de charge utile, de gravité — sa forme d'équivalent réprésentatif. C'est l'autre stade de la valeur qui l'emporte, celui de la relativité totale, de la commutation générale, combinatoire et simulation. Simulation, au sens où tous les signes s'échangent désormais entre eux sans s'échanger du tout contre du réel (et ils ne s'échangent biens, ils ne s'échangent parfaitement entre eux qu'*à condition de* ne plus s'échanger contre du réel). Émancipation du signe: dégagé de cette obligation 'archaïque' qu'il avait de désigner quelque chose, il devient enfin libre pour un jeu structural, ou combinatoire, selon une indifférence et une indétermination totale, qui succède à la règle antérieure d'équivalence déterminée." Jean Baudrillard, *L'échange symbolique et la mort* (Paris: Editions Gallimard, 1976), pp. 20, 18.

7. Baudrillard, "Fetishism and Ideology," *For a Critique of the Political Economy of the Sign*, trans. Charles Levin (St. Louis: Telos, 1981), p. 96, n. 10.

In the "Glamour" issue when General Idea write "An object exhibits unashamedly a closure and a brilliance, in a word a SILENCE which belongs to the world of myth," we could add Baudrillard's

comment that "What fascinates us is always that which radically excludes us in the name of its internal logic or perfection: a mathematical formula, a paranoic system, a concrete jungle, a useless object, or, again, a smooth body, without orifices, doubled and redoubled by a mirror, devoted to perverse autosatisfaction." *Ibid.*, p. 96.

8. A piece called "Composition/Decomposition" which records a performance of the "destruction" of the "Pavillion" in 1977 is listed in the table of contents of *FILE*, "1984, A Year in Pictures" as "Construction/Destruction."

9. It should not be thought that with a turn to "archaeology" General Idea are switching allegiance to Foucault. We can compare a statement from a later project by General Idea, "Cornucopia," to a passage from Barthes' *S/Z* which suggests the partial reversibility of a writerly text. General Idea: "The amorphous world of meanings and functions has traditionally been articulated through the architectural act of construction. But the three artists of General Idea have re-introduced *de*struction into the architectural process. In their long-term project, the 1984 Miss General Idea Pavillion, ruins are created as quickly as rooms are built. Accumulated layers of function and meaning slip in and out of focus, creating a shifting constellation of images which is the Pavillion itself.

"One of the most complex groupings of imagery and artifacts is 'the room of the unknown function.' Does this room perversely have no function at all? Or is that function too mysterious to penetrate? The objects reproduced here were originally located in this museum-like room. In these objects the dense web of iconography, which is the Pavillion, is unveiled. Imagine these shards as nodes of thought, imaged points of intersection erected in the network of motifs and themes from which the Pavillion is constructed and its fragments dis-

persed." General Idea, "Cornucopia," in Elke Town, *Fiction*.

Barthes: "We are, in fact, concerned not to manifest a structure but to produce a structuration. The blanks and looseness of the analysis will be like footprints marking the escape of the text; for if the text is subject to some form, this form is not unitary, architectonic, finite: it is the fragment, the shards, the broken or obliterated network — all the movements and inflections of a vast 'dissolve,' which permits both overlapping and loss of messages." Barthes, *S/Z*, trans. Richard Miller (New York: Hill and Wang, 1974), p. 20. The escape from the burning "Pavillion" is an escape of, not from, the text.

10. Baudrillard has commented on the loss of referentiality and interchangeability of theories during the '70s:

"La production théorique, comme la production matérielle, perd ses déterminations et commence à tourner sur elle-même, décrochant 'en abyme' vers une réalité introuvable. Nous en sommes là aujourd'hui: dans l'indécidabilité, à l'ère des *théories flottantes* commes des monnaies flottantes. Toutes les théories actuelle, de quelque horizon qu'elles viennent (et psychanalytiques aussi bien), de quelque violence qu'elles s'arment et prétendent rétrouver une immanence, ou une mouvance sans référentiels (Deleuze, Lyotard, etc.), toutes les théories flottant et n'ont de sens que de se faire signe les unes aux autres. Il est vain de les requérir sur leur cohérence avec quelque "réalité" que ce soit. Le système a ôté toute caution référentielle à la force de travail théorique comme à l'autre. Il n'y a plus de valeur d'usage de la théorie non plus, le miroir de la production théorique est fêlé lui aussi. Et ceci est dans l'ordre. Je veux dire que cette indécidabilité même de la théorie est un effet de code. Pas d'illusion en effet: cette flottaison des théories n'a rien d'une 'dérive' schizophrénique où les flux passeraient librement sur les corps sans

organe (de quoi? du capital?). Elle signifie simplement que toutes les théories peuvent désormais s'échanger entre elles selon des taux de change variable, mais sans plus s'investir nulle part, sinon dans le miroir de leur écriture." *L'échange symbolique*, p. 21, n. 1.

General Idea's *Magic Cocktail Palettes*, both as objects in the *Colour Bar Lounge* and as an "advertisement" in the videotape *Test Tube*, valorize the same notions in terms of inhabitation:

"Have you got a drinking problem? Do you feel confused when faced with today's bewildering choice of drinking possibilities? Do you find it difficult to make up your mind? Does 'never mix, never worry' prevent you from enjoying the full spectrum of drinking combinations? Have you got a drinking problem? Do you resent the traditional dogma of wine in glasses, brandy in snifters? Don't you long to mix aesthetics, dodge expectations, be creative? Would you like to vary your contents without being labelled neurotic or schizo? If you have a drinking problem, General Idea has the answer. At the Colour Bar we call it...the solution. With this handy tray and glasses you can mix yourself multiple drinks and not worry about incompatible rhetorics. Tired of those same old contents? With these magnetic glasses you can always spill the contents without breaking the context and fill them up again. Remember, the solution. Decision-making is obsolete...at the Colour Bar Lounge." *FILE*, 4:4 (Fall 1980), pp. 32-33.

11. "It stems from the fact that a Theory of the Text cannot be satisfied by a metalinguistic exposition: the destruction of metalanguage or at least (since it may be necessary provisionally to resort to metalanguage) its calling into doubt, is part of the theory itself: the discourse on the Text should itself be nothing other than text, research, textual activity, since the Text is that *social* space which

leaves no language safe, outside, nor any subject of the enunciation in a position as judge, master, analyst, confessor, decoder." Barthes, "From Work to Text," in *Image-Music-Text*, ed. and trans. Stephen Heath (Glasgow: Fontana/Collins, 1977), p. 164.

12. Barthes, *S/Z*, p. 20.

13. "Desire is anti-capitalist. Present economies of production and distribution do not allow for an economy of desire. Nevertheless, 'the bureaucrat strokes his files.'

"But as capitalism's complex resonance amplifies strange new need, its mushrooming electronic communications gadgetry creates hiding spots in tangled circuitry for perverted modern lovers...Two men, two telephones and certain electronic circuitry (established for entirely different reasons) combine to form a simple desiring machine. The gay connection is particular here, because gay eroticism is group eroticism (as distinct from group sex).

"So, too, the punk machine: 200 fans in a closed environment pump and strain in pogo rhythms, sex pistols, an essential component of the musician/audio equipment/audience desiring machine. Spitting provides the electrical connection that bypasses the contained sexuality of the family to power this group desire.

"This is an anarchist motion by definition: decision-making is not a reflection of hierarchical control of groups or masses (Capitalism/Fascism) nor of theoretical Marxist equalities. In anarchy desire is restored to its central orchestrating role.

"The patterns of desire are networks riddling the logics and the hierarchies of our capitalist/socialist superstructure. As the superstructure weakens, these patterns become apparent." AA Bronson, "Pogo Dancing in the British Aisles," *FILE*, 3:4 (Fall 1977), p. 17.

14. "As we shall see, capitalism is the only social machine that is

constructed on the basis of decoded flows, substituting for intrinsic codes an axiomatic of abstract quantities in the form of money. Capitalism therefore liberates the flows of desire, but under the social conditions that define its limits and the possibility of its own dissolution, so that it is constantly opposing with all its exasperated strength the movement that drives it towards this limit." Gilles Deleuze and Félix Guattari, *Anti-Oedipus: Capitalism and Schizophrenia* (New York: Viking, 1977), pp. 139-40.

"Mais la déliaison des énergies est la forme même du système actuel, celle d'une dérive stratégique de la valeur. Le système peut se brancher, se débrancher — toutes les énergies libérées lui reviennent un jour: c'est lui qui a produit le concept même d'énergie et d'intensité. Le capital est un système énergétique et intense. D'où l'impossibilité de distinguer (Lyotard) l'économie libidinale de l'économie même du système (celle de la valeur) — l'impossibilité de distinguer (Deleuze) la schize capitaliste de la schize révolutionnaire. Car le système est le maître...." Baudrillard, *L'échange symbolique*, p. 12, n. 2.

15. Delimitation can take place, as in Derrida, through a disruption of form. On the other hand, one can question the limit and edge as a strategy to disrupt the interior. Thus an art discourse can adapt the "concepts" and metaphors of a deconstructive, symptomatic or perverse inhabitation, a theorization of the margin and periphery in a valorization and extension of the limits, which at the same time are pockets (Barthes), the nomadic displacement or intensive drift of Deleuze or Lyotard, or the transgression of Bataille.

16. Any statement by Marx on value and its self-valorization is appropriate here. For instance: "It is constantly changing from one form into the other, without becoming lost in this movement; it thus

becomes transformed into an automatic subject. If we pin down the specific forms of appearance assumed in turn by self-valorizing value in the course of its life, we reach the following elucidation: capital is money, capital is commodities. In truth, however, value is here the subject of a process in which, while constantly assuming the form in turn of money and commodities, it changes its own magnitude, throws off surplus-value from itself considered as original value, and thus valorizes itself independently. For the movement in the course of which it adds surplus-value is its own movement, its valorization is therefore self-valorization. By virtue of being value, it has acquired the occult ability to add value to itself....

"As the dominant subject of this process, in which it alternately assumes and loses the form of money and the form of commodities, but preserves and expands itself through all these changes, value requires above all an independent form by means of which its identity with itself may be asserted. Only in the shape of money does it possess this form. Money therefore forms the starting-point and the conclusion of every valorization process." Karl Marx, *Capital*, vol. 1, trans. Ben Fowkes, New York: Vintage, 1977), p. 255.

Lukács extended Marx's analysis of the commodity to artistic conditions under imperialism that likewise is applicable here: "On the one hand, there arises an ever-more decided apology for imperialist capitalism, while on the other hand this apology is clad in the form of a critique of the present. The more strongly capitalism develops, and the stronger its internal contradictions consequently become, the less possible it is to make direct and open defence of the capitalist economy the centrepiece of an ideological justification of the capitalist system. The social process that led to the transformation of classical economics into a vulgarizing apologetics is at

work of course in other fields besides that of economics, and affects both content and form of bourgeois ideology as a whole. There is therefore a general estrangement from the concrete problems of the economy, a concealment of the connections between economy, society and ideology, with the result that these questions are increasingly mystified. The growing mystification and mythologization also makes it possible for the results of the capitalist system, which appear ever more clearly, and cannot be dismissed even by the apologists themselves, to be in part recognized and criticized. For the mythologizing of problems opens a way to presenting what is criticized either outside any connection with capitalism, or else giving capitalism itself so evaporated, distorted and mystified a form that the criticism does not lead to any kind of struggle, but rather to a parasitic aquiescence with the system..." Georg Lukács, "Expressionism: Its Significance and Decline," *Essays on Realism*, trans. David Fernbach (Cambridge: MIT, 1981), pp. 81-82.

17. "...the exchange of commodities originates not within the primitive communities, but where they end, on the borders at the few points where they come into contact with other communities. That is where barter begins, and from here it strikes back into the interior of the community, decomposing it." Marx, *Capital*.

18. Wilhelm Reich, *The Mass Psychology of Fascism*, trans. Vincent R. Carfagno (New York: Simon and Schuster, 1970), pp. 101, 98-99; Max Horkheimer and Theodor Adorno, *Dialectic of Enlightenment*, trans. John Cumming (New York: Seabury, 1972), pp. 209-210; General Idea, Showcard 1-084, published in *General Idea's Reconstructing Futures*, Toronto, 1978.

19. One of General Idea's latest works, and first commission, was for the Toronto Stock Exchange, 1983.

This essay was first presented as a lecture in the YYZ series, "The Practice of Pictures," February 14, 1984, and published in *Vanguard* magazine, Vol. 13, No. 4 (May 1984), pp. 10-14.

# Axes of Difference

*Representation Versus Expression in Toronto Art*

Toronto is neither New York nor Germany, let alone Italy. Yet there is a desire to institute a discourse in Toronto on the order of elsewhere — on the authority of that production, legitimation and history. Differences immediately arise in that history and culture we share but on our part cannot naturally inhabit, and in the power of legitimation we both command. Theirs is the power to originate and legitimate; ours is the power, really a lack of power, to receive and repeat.

This desire to institute a discourse from elsewhere to support a local practice has to order its form — and thus its content as well — as reception. This form, the form of reception, is the condition of our art here. It is a semiotic strategy on the same order as advertising. That is, it puts itself into place and maintains itself as a manipulation of signs within an already determined system. That system comes from elsewhere, and it is disseminated under the conditions of semiosis itself. The consequences: semiotics replaces history; simulation replaces action. (When I use the term "semiotics" or "semiotic practice," I use it simply as a descriptive term for a process, the process by which

something functions as a sign: that is, in the case of art, the conditions under which images are produced and circulated and meanings constructed.)

The masters of this strategy in Toronto, of course, are General Idea. They introduced and refined it in semiotic terms as a system, as a total package, a campaign in fact, in this city. But this semiotic strategy is never far away in practice when a place receives its information, strategies *and* desires through images and a text mediated elsewhere: that is the role of art magazines of glossy or academic stock. (And it is the process by which the mimetic triangle of emulation and rivalry institutes itself.) Nevertheless, the influence of General Idea is still direct. Those who want to kill the father and usurp his place only internalize his laws. I think of the actions and statements of Chromazone. The copying of strategies here replaces the formation of the superego as psychoanalysis describes the process. Emulation is masked by hostility. The other side of this fixation is represented by John Bentley Mays' elevation of General Idea and their strategies to *the* history of Toronto art; the contemporary history of this city merely being a playing out of an homage to this authority. In this return that painting now makes to the strategies of General Idea, the products are again secondary to the promotion, as an effect of the form of this semiotic system: the form — and that is the form of reception — is more important or determinant than the content or images. But an individual product today, i.e., painting, cannot have the consistency or coherency of General Idea's system. (The "re-materializa-

tion of the art object" was realized, after all, in the context of General Idea's semiotic practice: *FILE*, 5:2, 1981.) So self-reference, which we find in General Idea, is replaced by reference to a system elsewhere. This reference will take different forms: to another place, another time, another history, another world.

That discourse is taken to be painting. Painting takes itself to be the dominant discourse best able to deal with contemporary issues. While the issue today is representation in general and across media, in a changed economy of art painters have pushed themselves to the fore, and the issues are popularly seen to be those of painting. This is promoted by painters and journalists alike, blinded by the immediate, with the forgetfulness journalism instills and painters desire for their own originality. The whole impact is a tendency to obscure recent history, while at the same time denying the possibility of a local history; of desiring attention for what is here by repeating what gathers attention elsewhere.

A discourse is being instituted by declaration — a discourse that comes from elsewhere and that changes local history. Painting was already latent here as a practice, though not as a necessity, which is why a discourse, as distinct from a practice, was absent. The return to painting that Toronto is following from other centres has a singular expression here. It is a lack. Elsewhere the return to painting is accompanied, through the very practice of painting, by a national history, a means, as Benjamin Buchloh has pointed out, of product protection. What is the national

identity we promote and protect here through a return to painting? It is the lack of a history; and so we repeat one from elsewhere, or from Western art history, but without the grounding of history or context. This is not a postmodern condition: it is our condition. Once again, this practice operates on a semiotic level, but by choice.

What is at stake then, given that this return in Toronto either marks a genuine cultural expression and shift in art practice or on the contrary is a product of market manipulation? The irony here is that we have no market to back the claims of this return, so that divorced from its reality elsewhere this return or reproduction is a pure ideological reflex. In Toronto does this return indicate an historical development or merely a semiotic shift brought about by changing strategies for success?

If we find that it is a question of representation in and across media, and not a painting discourse alone, and not simply figuration, then it is a question of the status of the image — its practices, power and effects, which are issues of representation. I find that for us it is also a question of what is local and progressive; and that only the local can be progressive. By progressive I mean maintaining a contact with the real as that real changes. Does some art develop from a recent history of art here, our history or at least the making of a history, an art and history not transplanted from elsewhere? At the same time, is there some art that deals with issues of the real, whether in representation or not, rather than with that other simulation of history — art history — and the formal semiosis

and references it offers to a discourse within the security of the art gallery? I believe there is; and these lines of difference must be drawn.

Local and real: these are matters, paradoxically it may seem to some, of representation. And if representation (as distinct from ideology) can lead to an effect, representation can lead to action. So action becomes part of a concern for history — local history and the real. It is a matter of what is real for *us*. These matters are the real conditions of the art community and the real conditions of representation.

What are the lines of difference that must be drawn? It is not simply a line between formal or representational art and political art, or an art that delegates for itself the voice of politics. Outside of this divisive opposition, I think that there are two axes of difference in current Toronto work on representation. One is between expression and mediation, or appropriation we might call it. If we restricted ourselves to painting alone that opposition would not be completely descriptive of conditions in Toronto: we do not have an overtly expressionistic tendency as in Germany, for instance. Expression, like mediation, crosses over media: it is not restricted to painting alone. It is representation actually that is opposed to expression, not appropriation; these latter both project ideal subjects: an ideal presence; an ideal objectivity. So in fact the opposition is between representation and expression in general. The other axis of difference is between the current work by men and women in Toronto. This seems predominately to

align itself along the former axis — representation for women, expression for men, which does not mean that we will not find examples where the terms are reversed.

If the terms of the discourse have been changed to "representation" from "painting," then it cannot be a question of the discourse of a single medium. Rather it is a question of what we might simply call content, but in the end is representation. All these works by both men and women accept a frame; but while they share forms or media, the contents are different. If these works share the same forms and conditions, what accounts for the differences? It can only be that the content, its representation and forms of technique are symptomatic; and the work can be read for these symptoms. This symptomatic approach makes the questioning more than content analysis.

Symptomatic of what? The lines of difference are not so much those between expression and mediation, men and women; they are really between a passive resignation and melancholy despair, pessimism, nihilism and decadence on the one hand and the sense of the possibility of action on the other. In other words, it is what the works *lead to* that is the important question. It is a matter then of how they function rather than what they mean, of what their effects are rather than how their intentions are articulated outside the work. All of this work is not overtly political in its intentions or content; its effects are since they determine what position we wish to take or are assumed to take in that world outside the work.

How do I characterize the differences between the work

by men and that by women? Is it fair to create this oppo-
sition, or am I generalizing from a few select examples?
There are two positions that anyone can assume outside
of gender — activity and passivity might be two terms
for them; but I do see them currently being filled accord-
ing to gender: activity by women, passivity by men.
Gender difference is not defined essentially, but socially.
Women today are best prepared to deal with conditions
of representation because of the historical social condi-
tions under which they have been represented and the
analyses they have had to produce. At least they have
chosen to deal with them.

I would like to characterize the differences here in sets
of oppositions. We seem to witness an access to power by
women accompanied by a sense of loss of power by men
in an inverse proportion, marked by a confidence and a
withdrawal respectively. This access and confidence leads
women to deal with representational practices, as instituted
by modern forms of communication and reproduction;
the sense of loss of power and withdrawal by men leads
to a retreat to art history and tradition. Thus the referents
for subject matter and practice are located in the real
for women and the gallery and art world for men. Even
though this women's work partakes of the same frame
and context as the work by men, this does not imply that
their discourse has changed completely to accommodate
that frame. This women's work seems grounded by a well-
thought out structure and concept displaying the forma-
tive impact of a working process and method — a concern

for the context of the practice in general. This indicates that the work, even though it might have the appearance of paintings at times, follows through from the critical and contextual art of the recent past: conceptual, installation, video, performance, photo-textual, etc. Does this mean that women have gained competency in these forms just when the rules of the game have changed? I think not. The works' references do not make sense within a changed economy of art alone, a condition which accounts for the immediate appeal and easy "mastery" of men's work dependent on its semiotic relation to other images only.

These oppositions lead to fundamentally opposing beliefs: that one is able to act in the real (through representation changing representation); or, on the contrary, that it is *impossible* to act in the real, that one is able only to create emblems of that failure. That impossibility, like gender distinction, has been historically and socially determined; it is not an objective, ontological conclusion, but pertains to our present historical, political and economic cycle. This impossibility is not just a symptom expressed in the work; it has been articulated verbally and has come to form in certain artworks as their content. Thus this inactivity has become justified in an accumulation of tokens: pictures adding to a storehouse of images that is called culture and tradition.

This retreat on the part of men does not mean giving up the field. Control of the cultural apparatus and the means of cultural validation does not automatically fall to women. Rather, as we have seen elsewhere, the retreat

effects itself within a traditional system — the gallery, art history and recurrent ties to the market — and a return to traditional values and techniques, where there is *mastery* still. One can act out one's spectacles of melancholy resignation or heroic affirmation of subjectivity as a complicity with and affirmation of the museum. One's resignation or subjectivity is rewarded in the institution and marketplace as a maintenance of male cultural values of a traditional nature. Thus we see male artists acting out and parading a range of decadent values alternating between idealist heroism and nihilistic despair. These are schizophrenically articulated between the demands of capitalism for novelty and marketable products and personalities, and the restraints of a repressive political order that does not offer the possibility of active public intervention. Thus in Toronto, where all the same conditions and rewards do not exist of course, we could characterize some of the recent work by men as a romantic idealism, private subjectivism, sentimental humanism or nihilistic expressionism.

In David Clarkson's recent sculpture, a critique of mastery in terms of its ideal technical rationality is made through a demand for unity of senses and emotions fragmented by the rational. The demand for wholeness against loss is a form of mastery expressed within a romantic idealism. Anti-heroism is its own romantic, individualistic heroism, trapped within the ideal and its nostalgia for immortality.

In Andy Patton's recently exhibited paintings, a retreat

from the public is made under the guise of a lament for the public. A fiction of a private self is formed through so-called public images. The content, the pathos of the subjects, the unyielding and withdrawn surfaces, the titles — *The Architecture of Privacy, The Struggle for Privacy* — the text running under the latter painting — "Each individual is an isolate, permanently non-communicating, permanently unknown, in fact, unfound" — all clearly articulate and justify this retreat into a private subjectivity. It is as if this demand for a private subjectivity restores the ultimate form of private property — that of consciousness — to the individual. Its conservatism is the historical opposite to the romantic above.

John Scott's sentimental humanism is marked by all the good intentions of nineteenth century reformers. Through this sympathy, individuals are generalized into a helpless mass of bunnies. These subjects, individuated only according to the expressions of their helplessness, are juxtaposed, outside of any analysis, to what globally threatens them — a humanized bunny to a jet fighter for instance. Sentiment is given over to remedying the symptoms, as a sympathy for helplessness, rather than attacking or analyzing the conditions and sources of that helplessness.

Marc de Guerre's paintings are the most violent response to this condition of sensed helplessness and social impotency. Frustration with a social reality leads to a wholesale condemnation of our social reality through a denial of history. The will to deny this history in favour of an essential and timeless humanism, which is a denial of the

human of course, is a will to destruction. And this venge-
ful will to destruction is really a will to self destruction
which accounts for the apocalyptic fury of the nihilistic
expressionism of his work.

For women, the conditions of subjectivity are entirely
different; it is not a new strategy to claim a position in art.
Subjectivity as a term is not something we necessarily
should give value to. What is truly subjective, however, is
social; it is not a matter of personality, presence or expres-
sion. Subjectivity is a process enacted in the contradictions
between the public and private. It is not a withdrawal from
or opposition to the public, objective, rational, technical,
whatever. Subjectivity is not a freely assumed condition —
the personal appropriation or absorption into the unity
of a consciousness as compensation for frustration else-
where. Historically it seems that when men can no longer
act in the world, they recuperate that mastery subjectively.
The conditions and sites of subjectivity are in active, con-
tradictory process, constructed in totality, not consumed
as content. One can be complicit in that construction
through consumption of that content or act within the
constraints of that construction through recognition of its
making. Representation seems to me to be a more objec-
tive condition and avoids subjectivity, or at least it displays
one's place within it. Expression does not. The work by
women to be discussed has a more intimate knowledge of
and care for the conditions of representation. To have the
conditions of representation inscribed within one, socially,
not essentially or biologically, is to be aware of the con-

Shirley Wiitasalo, *Interview* 1981.
Oil on canvas, 152.4 x 183cm.
Reproduced by courtesy of the Carmen Lamanna Gallery, Toronto.

ditions of representation in every aspect of one's own representational practice.

We can contrast the static absorption of a so-called public image in Andy Patton's paintings with the dynamic interplay between interior and exterior, "subjective" and "objective," public and private of Shirley Wiitasalo's paintings, whose subjects vacillate uneasily between containment and catastrophe. Patton's paintings are public insofar as the image is found published and then transformed in a unifying medium with its own history and associations. Wiitasalo's paintings similarly are framed in one medium, but an interior frame almost always mimes the edge of the canvas as a self-conscious division between inside and outside, and the subject itself is not assuredly unitary. Thus *Interview* (1980) accounts for the viewer by duplicating our conditions inside: our surrogate watches television as we look at this image. But this is no secure identity: television and figure merge and dissolve, constructing each other in the flickering roll of the image.

When this interior frame is a television or a domestic room, one realizes that the divisions between the inside and outside are socially set, while the social breaks down that division at the same time, penetrating and determining the private: thus the incursion of the public into the domestic in *Interior* (1980) with the television image of the Reagan assassination attempt filling the living room interior. On the contrary, violence is directed outwards as the domestic, in the form of a spinning "x-rayed" apartment block, seems to break into the social in *Expansive Expensive*

Shelagh Alexander *Untitled, Part 1* 1983 (Panels 1 & 2)
Photomontage, 101.6 x 127cm. each
Collection of The Ydessa Gallery, Toronto.

(1980). Thus the breakdown goes two ways, and is active both ways — from the public to the private and the private to the social.

That this subjectivity is a process of construction reinforced at every moment can perhaps best be shown in narrative. While paintings such as Wiitasalo's show its dynamic and ambivalent structuring, Shelagh Alexander's recent compilation photographs sustain that process and show its construction in sociality and representation through the mimicking of the devices of film. Thus the temporality of this construction of the subject unfolds in the mythic exaggerations of Hollywood movies aligned to paternal authority. As feminist film theoreticians have shown, film is one of the dominant social places for the construction of the subject of woman in the male gaze. This work of Alexander's, combining the archives of the personal in the form of family photographs with the mythic, dominating archetypes of popular culture, is not a critique of representation from without, but a complex registering within, where family and film merge in the authority of their images. As in Shirley Wiitasalo's paintings, its site is the distortions of the imaginary.

At the same time, however, this imaginary does not make the work unreal: the imaginary has real effects. In fact, the medium of photography cannot but help reflect the real or its construction: here there are both real subjects, i.e., family snapshots, and the reality of representation, i.e., film. Even though the two parts of the work, of childhood and adolescence, show the closing off of the universe of

possibilities for the female, they at least show its conditions and construction. In contrast, John Scott's bunnies show neither the conditions nor effects of their helplessness.

One is not only positioned in relation to representation through one's construction in and through representation, one re-positions oneself in analysis. Aware of these conditions of representation as an artist, one deals with their conditions in application as well. Like Shelagh Alexander, Janice Gurney appropriates images, but also practices — images of her past, and images that are the picture of her practice. But through the second procedure she positions herself more directly and obviously as a double subject. In Gurney's work, the identifications and distancings take place both in terms of subject matter and working process. So her activity is a re-marking of what is proper to her in history and artistic practice: her history and history in general, her practice and artistic practice in general. The use of one's own biological and cultural inheritance — the painted reproduction of an original tintype of the artist's grandmother as a child in *Portrait of Me as My Grandmother's Faults* (1982) — along with images by others, couples the power and authority of making, marking and depicting with a power and authority over others — those depicted. It is only by inserting herself doubly, in terms of being represented oneself in the image of the child and in terms of being in the position of power of the photographer of the famine victims, that representation can be beheld and used in its complexity — positively and negatively.

Janice Gurney, *Portrait of Me as My Grandmother's Faults* 1982.
Mixed media, 168 x 178cm.
Reproduced by courtesy of Wynick/Tuck Gallery, Toronto.
Photo credit: Peter McCallum.

The inseparability of practice and representation leads to a fragmentation all the same. For Gurney, fragmentation is a condition of representation, of appropriate distance in appropriating images by and of others. These are set in representational practices but not unified by the necessary mediation of the artist. For David Clarkson, fragmentation is only the lack of a desired unity. Instead of the distancing of representation, whereby we enter critically into the conditions of a discourse, the artist is fully present in his expression.

The dialectic of master and mastered is inhabited by women's position here as artists: that is, as an artist — a mastering subject, but as a woman — a traditionally mastered subject. The ultimate mastery that that dialectic implies, however, is denied by social reality, since it is not a movement of sublimation or overcoming but a contradictory inhabitation of both positions at once. So in Joanne Tod's *Self Portrait* (1982), who or what is the *objet de luxe*, the woman in the painting or the painting, both identified in the figure of the artist since the painting is labelled a self-portrait? We find an identification between the representation of women and the social function of painting, both of which cohere in this artist. This ambiguity and identity is heightened further in *Self Portrait as Prostitute* (1983) with the depiction of the earlier *Self Portrait* in a domestic bourgeois setting. Now through the surrogate of the painting, the artist is represented as a commodity prostitute, as a purveyor of luxury goods to the bourgeoisie; but a further identity is established in plac-

Joanne Tod, *Self-Portrait as Prostitute* 1983
Acrylic on canvas, 140 x 177.8cm.
Reproduced by courtesy of the Carmen Lamanna Gallery, Toronto.

ing the glamourous object of woman/picture in a domestic place: the poles of contradiction — woman as object, woman in her domestic place, artist as woman, artist as object, i.e., the name and value of the work — align. *Identification/Defacement* (1983) plays on the same contradictions we saw in Janice Gurney's work, the contradictions of relations of power within representation. With the printing of the artist's name across the eyes of a black woman in wedding dress in two similar panels, identification and defacement take place within the structure of the Other. This identity in negation is the irony that Tod is able to use to such effect.

While an awareness of the structure and power of representation gives Joanne Tod the ability to use irony for recognition and negation, for Marc de Guerre negation can only be destruction. Without the mediation of representation, negation becomes an absolute presence, in other words, absolute destruction. Without the ability to negate which irony or representation allow, in frustration everything has to be destroyed.

In conclusion, where do I stand in drawing these lines of difference? I start from the position of my interest: what art can account for what is local and real which I think are the authentic conditions of an art community, and which find expression in more than just artworks. These are the conditions of our history or lack of a history as well as the genuine conditions of others' interest in our art. It seems that the structure of representation, in no matter what medium, allows this, because representation has to

account for both relations and places — the position and relation of the artist and viewer to each other and to that subject represented and the context of the practice itself. What leads to the local and real, to the possibility of acting within one's own history, and what leads away, and why? Action becomes an important concept. What leads to its possibility and what leads away determined the divisions outlined above.

This essay was first published as
the introduction to the exhibition
catalogue *Subjects in Pictures*
(Toronto: YYZ Artist's Outlet),
1984.

# Subjects in Pictures

For this exhibition, "subjects in pictures" is to be taken doubly. There are subjects *of* pictures and subjects *in* pictures. On the one hand, by "subject" I mean the general content or "meaning" of the picture. And by picture I mean an enclosed representation, whether framed in the medium of painting, photography or drawing. On the other hand, by "subject" I also mean an individual. The depiction of a man or woman in a picture is more than figuration, because that figure is represented in subjecthood, as an "individual." The picture is a means of depicting subjects as content and representing subjects as individuals: in short, subject-matter and subjecthood.

The definition of the political "subject" as a free agent also lends itself to one who is *subjected*. By now we are aware that the image plays a part in this subjection. In subjecting the viewer to its look and construction, the image helps constitute a subject. That construction occurs as an ideological process, more in the unconscious than through consciousness. The individual is not fully and freely given as a subject of consciousness, an identity that one can possess. Nor is the image just the source and ground for its

subjective counterpart in aesthetic reception. Picture and subjecthood are constituted and instituted: they are both constructed in representation. (The image here is more than its appearance in depiction. "Image" is really a shorthand for the expression "social relations of the image," the social relations implied in what is depicted as well as the social relations that institute and disseminate that image. The image is placed here for our reception by an institution that greatly determines its interpretation.)

That the image can lead to subjection does not lend countervalue to subjectivity — that process of the fragmented ego's "interior" consumption which pretends to escape the dominance of the media or the alienation of consumption and labour. For the purposes of this essay, subjectivity is accepted as a social construction.

The subject, like meaning, is never stable. The subject of women and woman as subject enter as a double disturbance in artistic practice and discourse. In this exhibition of six women artists, the work is conscious of, if it does not pursue it as a direct theme, the subjection of women in representation. But it is also much more, for the work takes itself as a site for the construction of subjectivity in general and for the questioning of identity.

Within representation, women's position can be contradictory. In the case of artists, women are mastering subjects; but as women they are traditionally mastered subjects. Therefore the artist is a mastering/mastered subject. The ultimate mastery that the dialectic of master and mastered implies, however, is denied by social reality, since it

is not a movement of sublimation or overcoming but an impossible inhabitation of both positions at once. Moreover the contradiction is further complicated in art since the dialectic occurs within the look.

The work by these artists situates subjectivity in and as an order of representation. At one time or another they have variously addressed issues of representation, subjecthood and women's (and men's) position in the ideological presentations of mass media — advertising, film, television, the means by which viewers are situated and subjected to the image. We are subjected to the image, a "reality" that has the power to constitute our very selves. Whether all the works are as direct as this, all depict one form of the subjective moment, the conditions for the constitution of the subject — and its undoing. As such, they do not stand critically outside these images or inhabit their codes in appropriation. But they are critical in contributing to a non-subjective theory of subjectivity.

Now is the time and turn of the image. The construction of the subject in subjectivity takes place through the image, *takes place* in the sense that the viewer is positioned in place socially by the image. If the subject is constituted primarily through language in the symbolic order, his or her identity is reinforced through the image, an image, however, that always carries a subtext with its look. But if as a subject one is the product of an image, a *process* has occurred. The works by these artists register and display the effects of the image, the process by which one is made into a product, or in other words a subject. The turning

of an individual into a subject is an active and continual temporal process by which a static structure is instituted and social relations are maintained.

This process has its objective and subjective moments, or rather an objective structure and a subjective process. Or we could term the two: structural relations and subjective distortions. The works by the artists divide along these "objective" and "subjective" lines. (Objective and subjective are not to be opposed as absolutes in their conventional or idealist senses.) Janice Gurney and Joanne Tod rest on the side of the objective (the objective within representation, that is); Shelagh Alexander, Sandra Meigs and Shirley Wiitasalo "err" on the side of the subjective. And Nancy Johnson seems to occupy a middle ground between the two.

The paintings or constructions by Janice Gurney and Joanne Tod set up objective relations of power within the work as references to power relations outside it, but also as paradigms for relations between image and viewer. It is because of this structuring that their work also makes a critical intervention in practice and viewing. A work cannot be critical that does not account for its attraction or for its own apparatus of power. Just as work cannot be critical that does not account for its own complicity in commodity exchange through the production and dissemination of images. The commodity form is implicated in the look. The look invests in the image of depiction, but also in the "look" and image of the work itself — its form of appearance, which is its commodity status. Since this particular

object (the artwork) carries all these investments, the structure of the look is also the site of a potential critique. The critique maintains itself within the same structure as the look, as a critique of the pleasure or dominance of the look, its investment in and as ideological figures. Gurney and Tod come at this from two different directions, within the structure or appearance of the work itself.

The position of the artist as master of the image, but also one mastered by images outside her control, blurs the distinction between inside and outside that Shelagh Alexander, Sandra Meigs and Shirley Wiitasalo take up. That is, the objective structures of Gurney's and Tod's work set up the conditions for a subjective (ideological) process to take place. In their own case, that objectivity is shaken by the contradictory positions of the artist that have been described here. In the works by Alexander, Meigs and Wiitasalo we witness the image transformed, or we see an interior transformation that is *signified* by this image. The image is a signifier for that process taking or having taken place. We are not given an image that can be taken as objectively constituted in the mass media or that can be received as its subjective impression. It is neither appropriative nor expressive. The process of ideological transformation is more than implied: its dynamic process is taken over, distorted, exaggerated, ending often in catastrophe.

This image of catastrophe marks a limit, a structural and social limit we could say, that could be posed by the first group of work, but not enacted. The catastrophe signifies a displaced action. But that action is more critique than

compensation. Rather than create emblems of failed social intervention, powerlessness or nihilistic allegories of melancholy, representation becomes a site of activity, not of regressive character identifications, but of the aggressive struggle of representations against representation.

The middle term between these two types is found in Nancy Johnson's drawings. This work starts with the interiorization of the look, and ends in a look that is self-directed, but that directs itself to and from an image. Having said that there are two types to which a third is added does not point to an opposition or to a resolution in the third term. Each occupies a different position in a process.

The artists share a place (Toronto), a situation and a practice. But they share more than the abstracted structures and processes outlined above. Their mutual concerns are realized within the processes of content and the temporality of looking. And those have their site and source, positively and negatively, in the image.

# Bibliography

*Articles*

"David Rabinowitch: Recent Sculpture," *Parachute*, no. 8 (Autumn 1977), pp. 22-24.

"Structures for Behaviour," *Parachute*, no. 12 (Autumn 1978), pp. 20-27.

"The Death of Structure," *Parachute*, no. 16 (Autumn 1979), pp. 32-35.

"Theoretical Dance: This Body is in Creation," *Only Paper Today* (Toronto), 6:8 (October 1979), p. 18.

"Stanley Brouwn and the Zero Machine," *Parachute*, no. 18 (Spring 1980), pp. 18-20.

"Exits," *Impulse*, 8:3 (Summer 1980), pp. 29-31.

"Violence and Representation," *Impulse*, 8:4 (Autumn 1980), pp. 34-35. Reprinted in *ZG*, no. 2 (1981), p. 3.

"Common Carrier" (1980), *Modern Drama*, 25:1 (March 1982), pp. 162-169.

"Arresting Figures" (1980), *Vanguard*, 11:2 (March 1982), pp. 18-21.

"Television by Artists," *Canadian Forum*, 61:709 (May 1981), pp. 37-38, 40.

"Breach of Promise," *File*, 5:3 (Spring 1982), pp. 36-37.

"Notes on the Sumptuary Destruction of Leaders," *ZG*, no. 8 (1982), n.p.

"Naming and Comparing: Robin Collyer," *Vanguard*, 12:1 (February 1983), pp. 13-16.

"Tom Sherman Presenting Text," *Parachute*, no. 30 (March-May 1983), pp. 26-32.

"Arguments within the Toronto 'Avant-Garde'," *Parallelogramme*, 8:4 (April-May 1983), pp. 30-36; French translation, pp. 61-67.

"Colony, Commodity, Copyright: Reference and Self-Reference in Canadian Art," *Vanguard*, 12: 5/6 (June 1983), pp. 14-17.

"Staging Language, Presenting Events, Representing History: Ian Carr-Harris, September 1973," *Vanguard*, 12:9 (November 1983), pp. 18-21.

"Editorials: General Idea and the Myth of Inhabitation," *Parachute*, no. 33 (December 1983-February 1984), pp. 12-23.

"Image of the Leader, Function of the Widow," *C Magazine*, no. 1 (Winter 1983-1984), pp. 40-45; extensive *erratum*, no. 2 (Summer 1984), p. 59.

"Archives, Editors and Activists: What's Wrong with this Photograph(er)?," *Fuse*, 7:6 (Spring 1984), pp. 292-296.

"Axes of Difference," *Vanguard*, 13:4 (May 1984), pp. 10-14.

"Queen Street," *Canadian Forum*, 64:741 (August-September 1984), pp. 33-35.

"Subjects in Pictures," *Parachute*, no. 37 (December 1984-February 1985), pp. 14-23.

"In Retrospect: Presenting Events," *Parachute*, no. 46 (March-May 1987), pp. 11-13.

"Presentations," *Artviews*, 13:4 (Fall 1987), pp. 20-26.

*Book Essays*

"Terminal Gallery/Peripheral Drift," *Spaces by Artists/Places des artistes*, Toronto: ANNPAC, 1979, pp. 32-35.

"Coming to Speech," *Performance*, Montreal: Parachute, 1981, pp. 145-148.

"Véhicule commun: artistes en performance," *Théatralité, écriture et mise en scène*, Montreal: Hurtubise HMH, 1985, pp. 113-123. (Translation of "Common Carrier.")

*Pamphlets*

*Peripheral Drift: a Vocabulary of Theoretical Criticism*, Toronto: Rumour, 1979.

*Catalogue Essays*

*Colette Whiten*, London: London Regional Art Gallery, 1978.

*Richard Evans, John Howlin, Robert MacNealy, Sam Perepelkin*, Toronto: Artists Cooperative Toronto, 1978.

*Ed Zelenak*, Saskatoon: Mendel Art Gallery, 1981.

*George Legrady*, New York: P.S. 1, 1981.

"A Space in Toronto: a History," *Künstler aus Kanada*, Stuttgart: Württembergischer Kunstverein, 1983, pp. 119-20; German translation, pp. 116-117.

"The Somnambulist," in *Artistes canadiennes/Canadian Women Artists*, Paris: Centre Culturel Canadien, 1985.

"Robin Collyer" and "Liz Magor," *documenta 8*, Kassel: Weber and
    Weidemeyer, 1987, vol. 2, pp. 50, 156. (German translation)

*Catalogues*

*Language and Representation*, Toronto: A Space, 1982.
*Subjects in Pictures*, Toronto: YYZ, 1984.
*Bernie Miller*, Toronto: Art Gallery of Ontario, 1985. (With Barbara
    Fischer)
*Liz Magor*, Toronto: Art Gallery of Ontario, 1985.
*Shirley Wiitasalo*, Toronto: Art Gallery of Ontario, 1987.
*Paterson Ewen: Phenomena*, Toronto: Art Gallery of Ontario, 1987.

*Reviews*

"Yves Gaucher: Eyesight and Temporality," *Parachute*, no. 16
    (Autumn 1979), pp. 47-48.
"Reading and Representation in Political Art," *Parachute*, no. 16
    (Autumn 1979), pp. 49-50.
"Pluralities: Experiment or Excuse," *Parachute*, no. 20 (Autumn 1980),
    pp. 48-49.
"Gerry Schum Tapes," *Parachute*, no. 22 (Spring 1981), pp. 46-47.
"German Video and Performance," *Parachute*, no. 22 (Spring 1981),
    pp. 49-50.
"John Scott," *Art Express* (New York), 1:1 (May 1981), p. 81.
"Janice Gurney," *Art Express*, 1:1 (May 1981), p. 81.
"Michael Snow: Presents," *Art Express*, 1:2 (September-October

1981), p. 65.

"Hurlbut/Martin/Massey/Singleton," *Parachute*, no. 24 (Autumn 1981), pp. 52-53.

"Violent Lens: Roland Barthes, *Camera Lucida: Reflections on Photography*," *Canadian Forum*, 61:714 (December 1981), pp. 36-37.

"Robin Collyer," *Artforum*, 20:7 (March 1981), pp. 77.

"Fiction," *Parachute*, no. 28 (September-November 1982), pp. 41-42.

"Shelagh Alexander: Hero," *Parachute*, no. 28 (September-November 1981), p. 42.

"Agit-Prop," *Parachute*, no. 28 (September-November 1982), pp. 42-44.

"Kunstler aus Kanada," *Parachute*, no. 31 (June-August 1983), pp. 46-47.

"Krzysztof Wodiczko," *Parachute*, no. 32 (September-November 1983), pp. 45-46.

"Museums by Artists," *Parachute*, no. 32 (September-November 1983), pp. 44-45.

"David Clarkson," *Vanguard*, 12:10 (December 1983-January 1984), pp. 34-35.

"Symposium on Photographic Theory," *Vanguard*, 12:10 (December 1983-January 1984), p. 49.

"Locations (Toronto)," *Vanguard*, 13:1 (February 1984), pp. 22-23.

"Production/ReProduction," *Vanguard*, 13:1 (February 1984), pp. 53-54.

"Ben Smit," *Vanguard*, 13:1 (February 1984), p. 46.

"Marc de Guerre," *Vanguard*, 13:2 (March 1984), pp. 40-41.

"Tony Brown," *Parachute*, no. 34 (March-May 1984), p. 51. Reprinted in *Tony Brown*, New York: 49th Parallel, 1984.

"Liz Magor: *Four Notable Bakers*," *Vanguard*, 13:3 (May 1984), p. 30.

"The Revolutionary Power of Women's Laughter," *Parachute*, no. 35 (June-August 1984), pp. 37-38.

"Oliver Girling," *Vanguard*, 13:5/6 (Summer 1984), pp. 41-42.

"Ian Carr-Harris, *Parachute*, no. 39 (June-August 1985), pp. 68-69.

"Lothar Baumgarten," *Parachute*, no. 49 (December-February 1987-1988), pp. 30-31.

"Material Fictions/Ideological Facts," *Parachute*, no. 49 (December-February 1987-1988), p. 55.

Philip Monk is the Curator of Contemporary Canadian Art at the
Art Gallery of Ontario, Toronto

Design by Bruce Mau & Micah Lexier
Cover Image from a film by Greg Van Alstyne
Typesetting by Canadian Composition Inc.
Printed by John Deyell Company